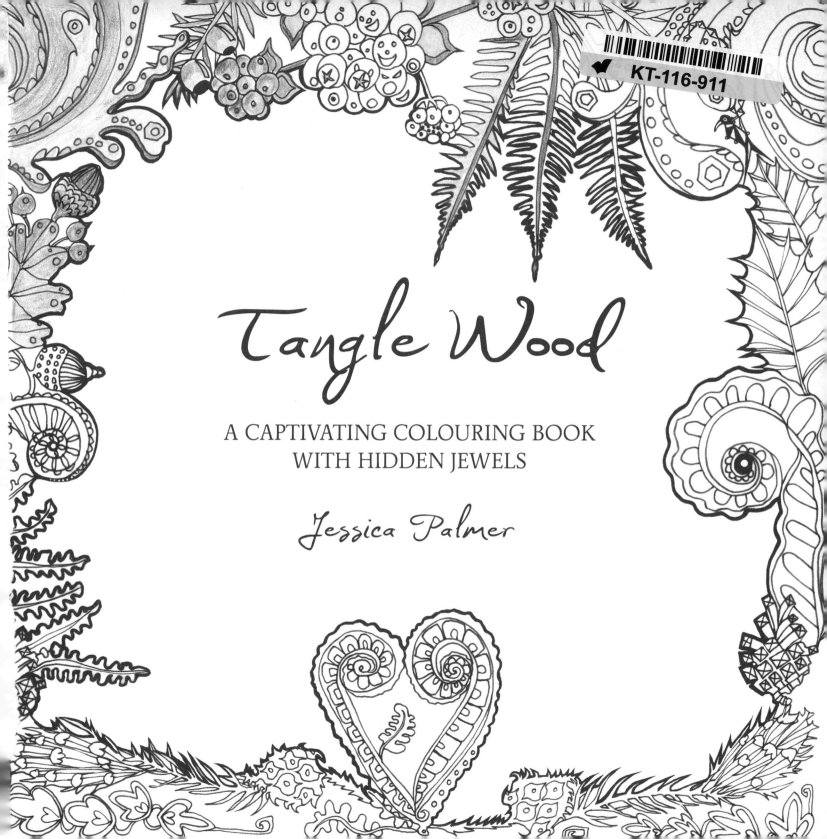

Tangle Wood

A CAPTIVATING COLOURING BOOK
WITH HIDDEN JEWELS

Jessica Palmer

Dedication

For Ian and Rachel, with love.

First published in 2015

Search Press Limited, Wellwood, North Farm Road, Tunbridge Wells, Kent, TN2 3DR

Text and illustration copyright © Jessica Palmer, 2015

Design copyright © Search Press, 2015

ISBN: 978-1-78221-353-6

The Publishers and author can accept no responsibility for any consequences arising from the information, advice or instructions given in this publication.

Readers are permitted to reproduce any of the items/patterns in this book for their personal use, or for the purposes of selling for charity, free of charge and without the prior permission of the Publishers. Any use of the items/patterns for commercial purposes is not permitted without the prior permission of the Publishers.

Printed in Poland

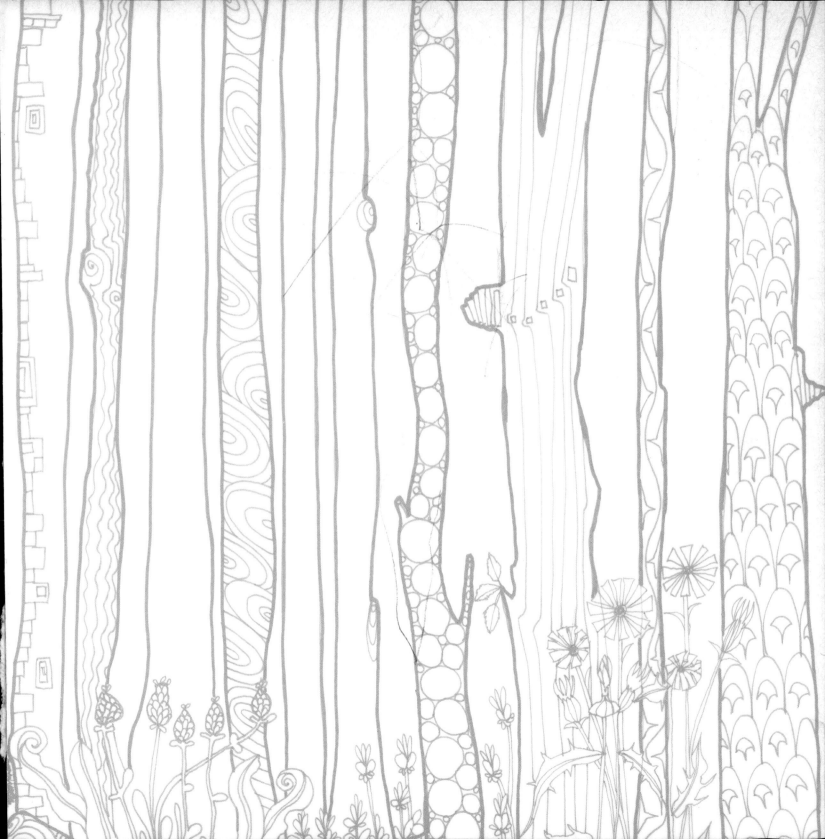

This book belongs to:

..

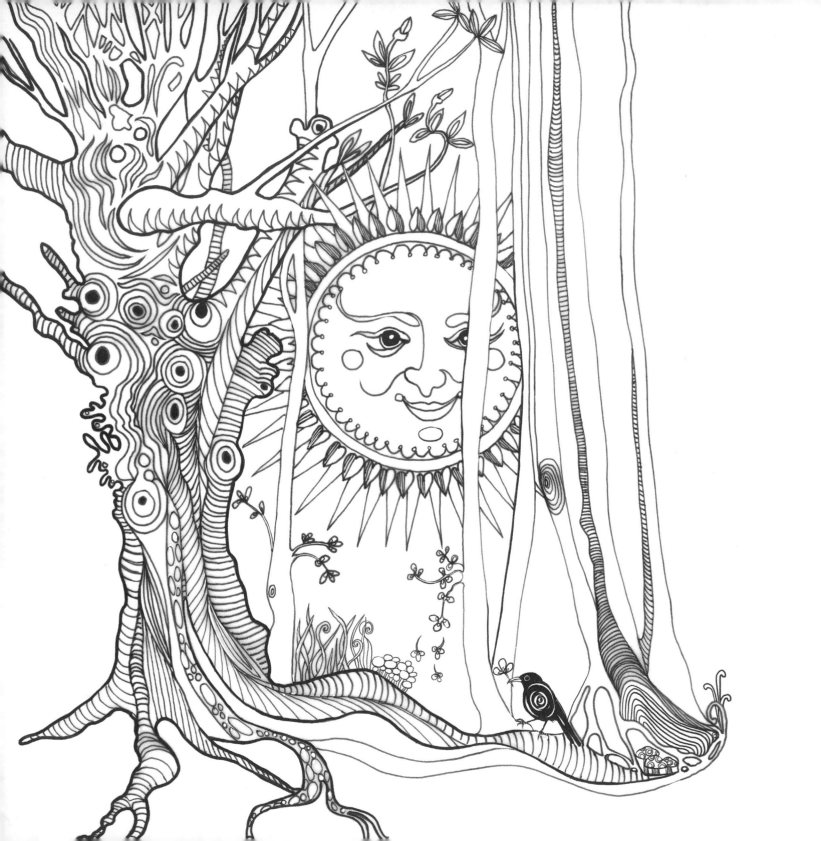

Welcome to Tangle Wood

Come inside and discover a magical place full of woodland creatures, fairy objects and a tangle of mysterious plants and gorgeous flowers.

Hiding inside every picture is an animal charm for you to find, waiting for your jewel colours. You could use a fine-nibbed black pen to add patterns, or try watercolour pencils or brush pens for beautiful effects of your own.

This is a place to let your imagination wander. Down a path.
Into the forest. Under a hedgerow. Over the moon.
And it's a space for you to be creative.
To draw and doodle in the airy spaces.
To colour to your heart's content.

It's time to lose yourself…in Tangle Wood.

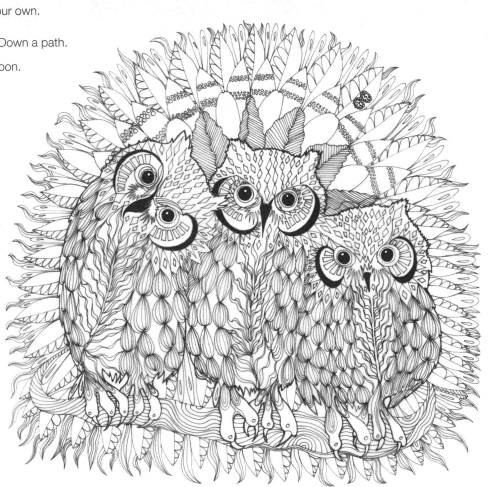

These are some of the jewels hidden in Tangle Wood:

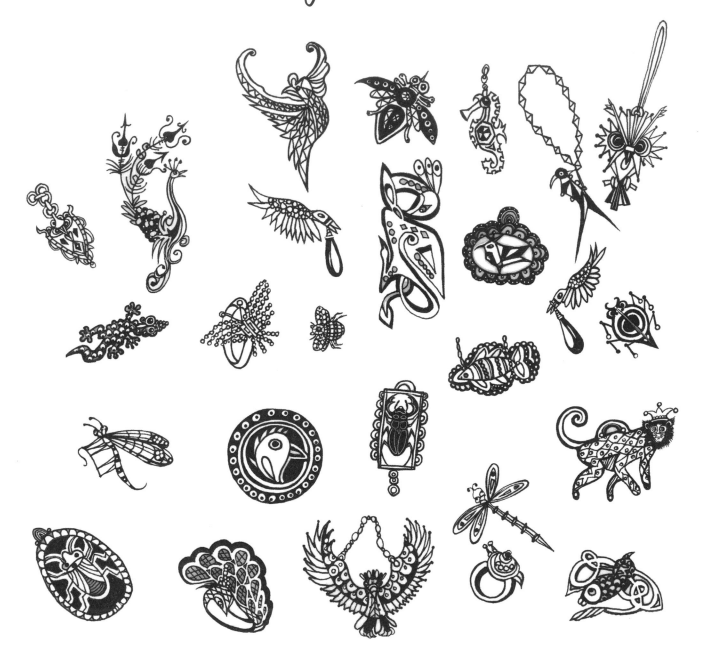

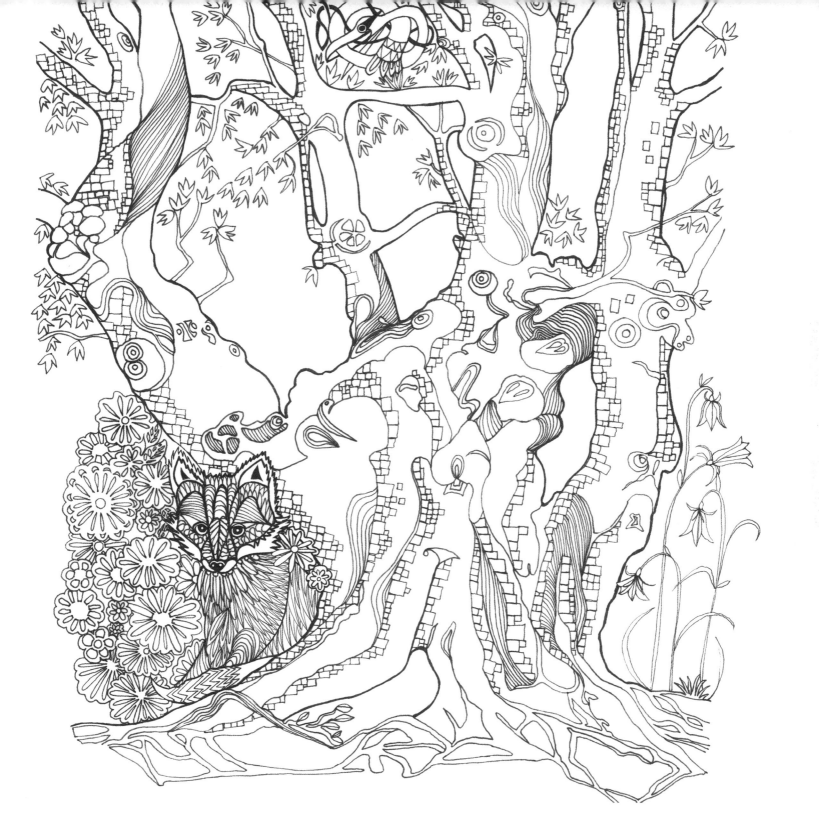

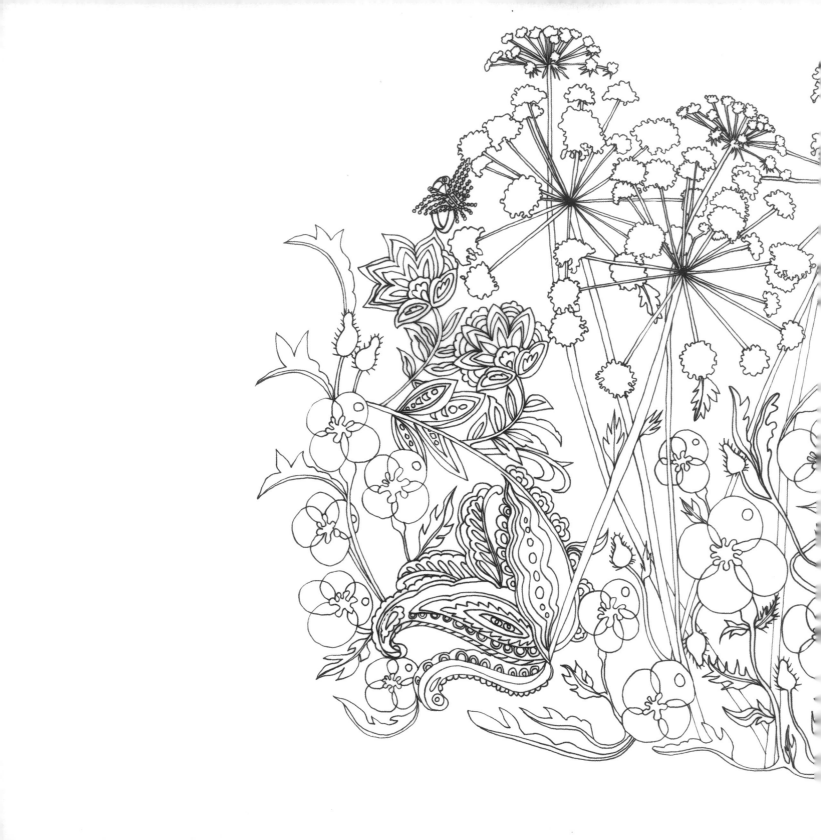

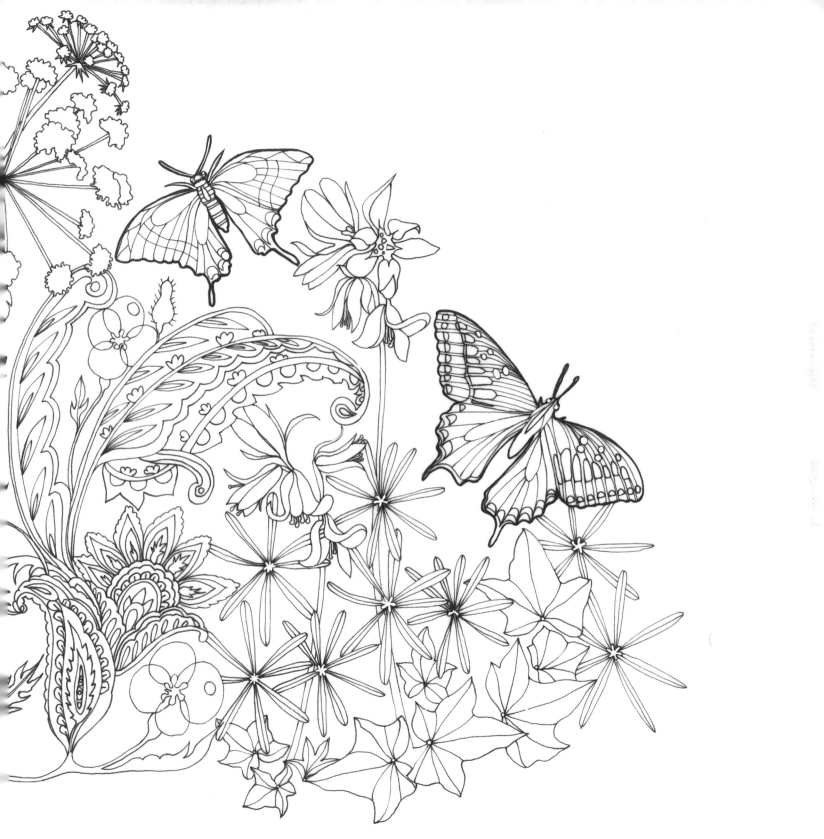

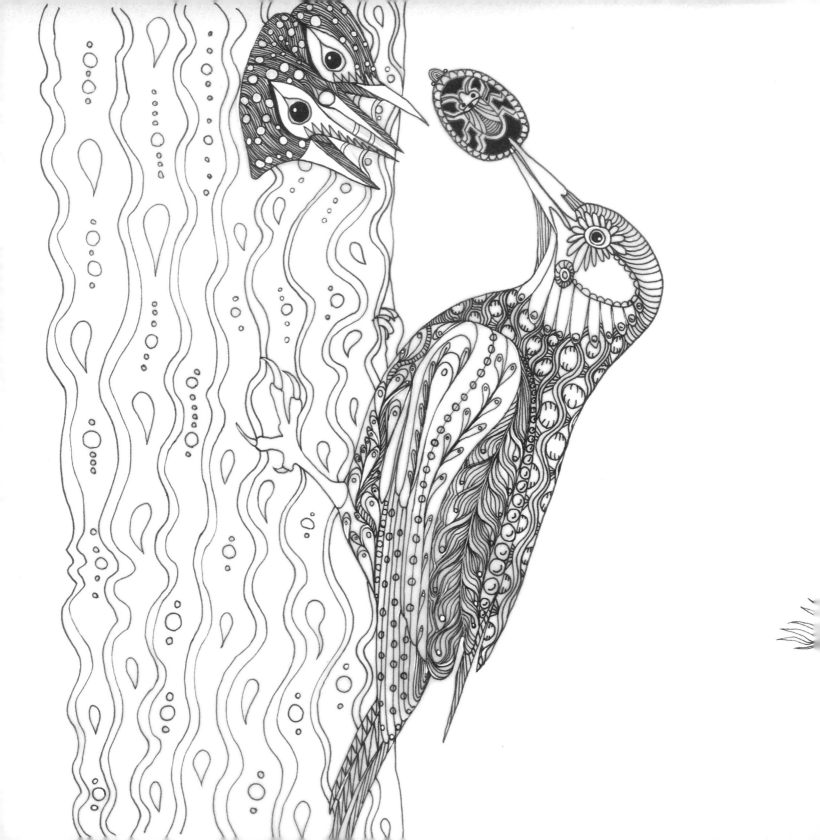

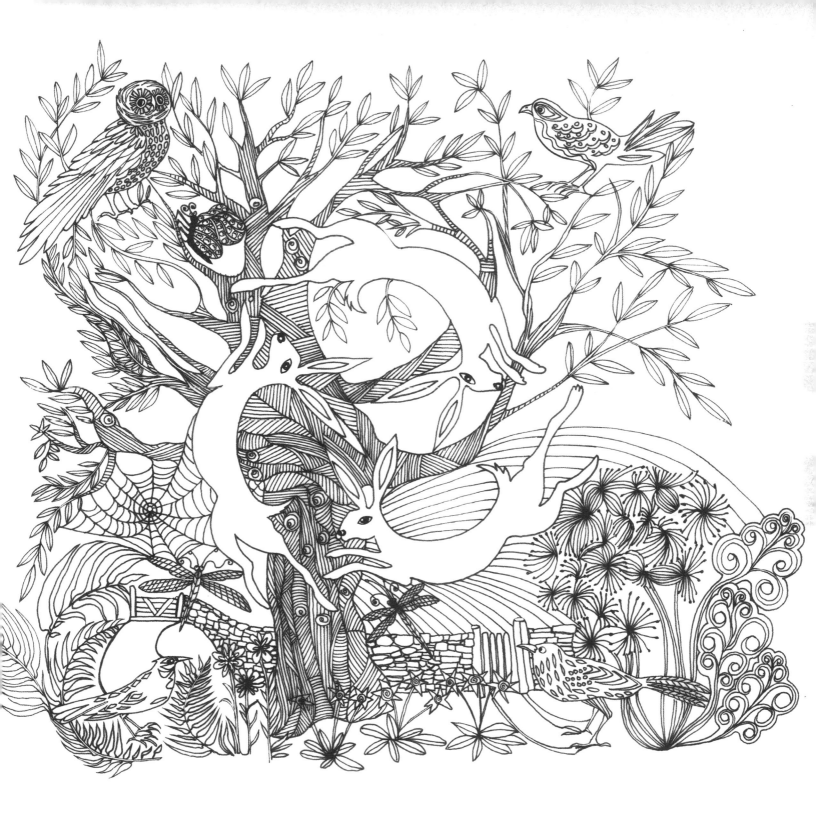

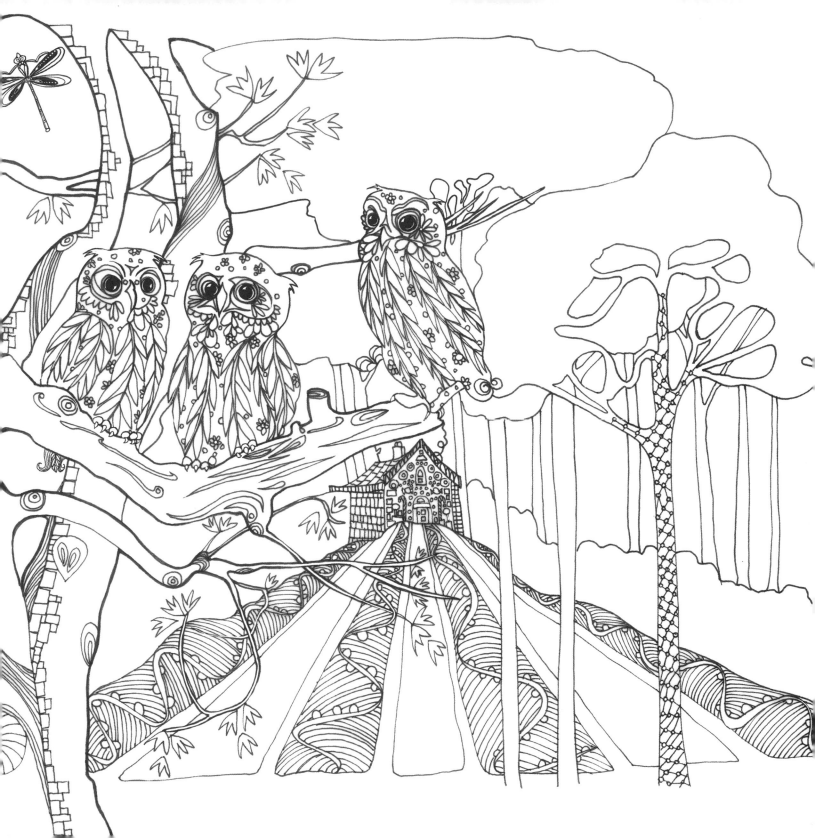

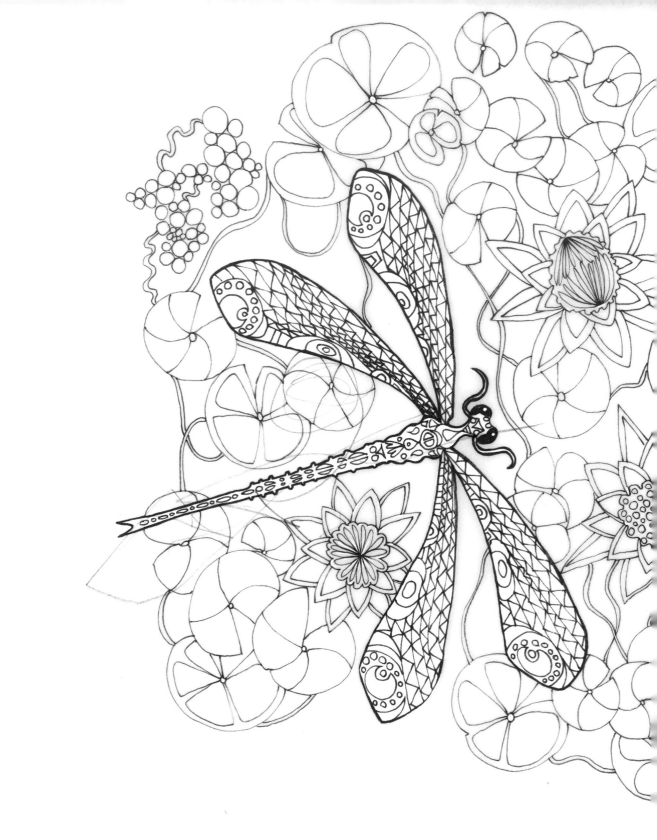

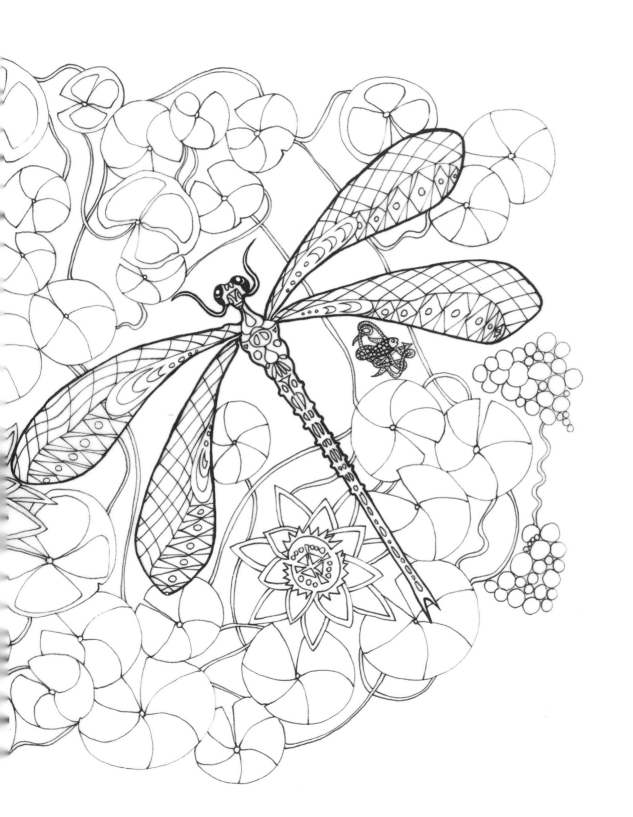

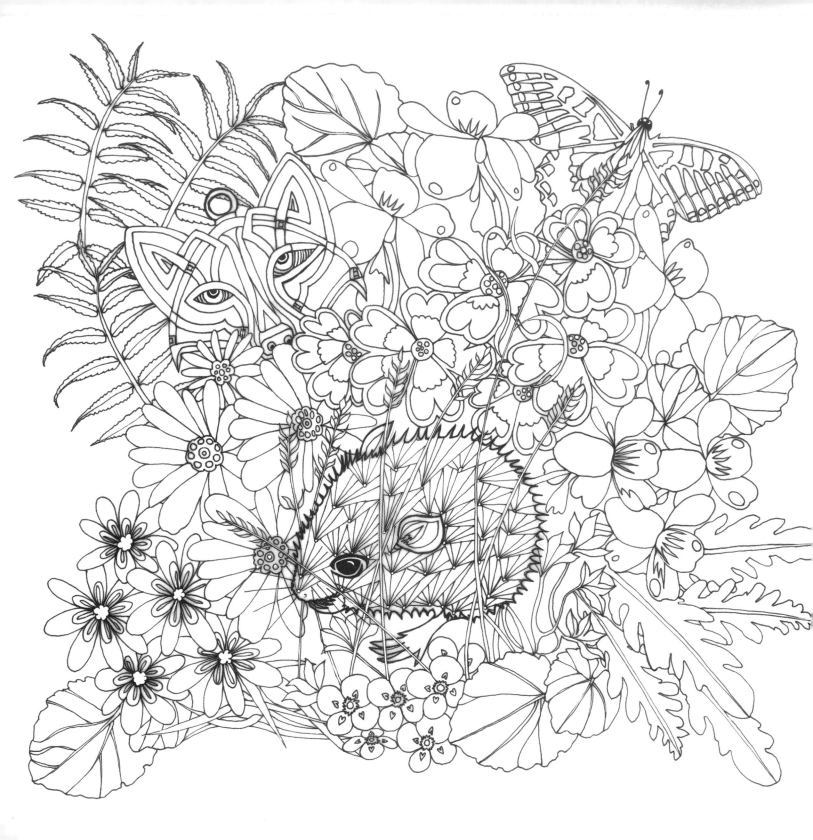

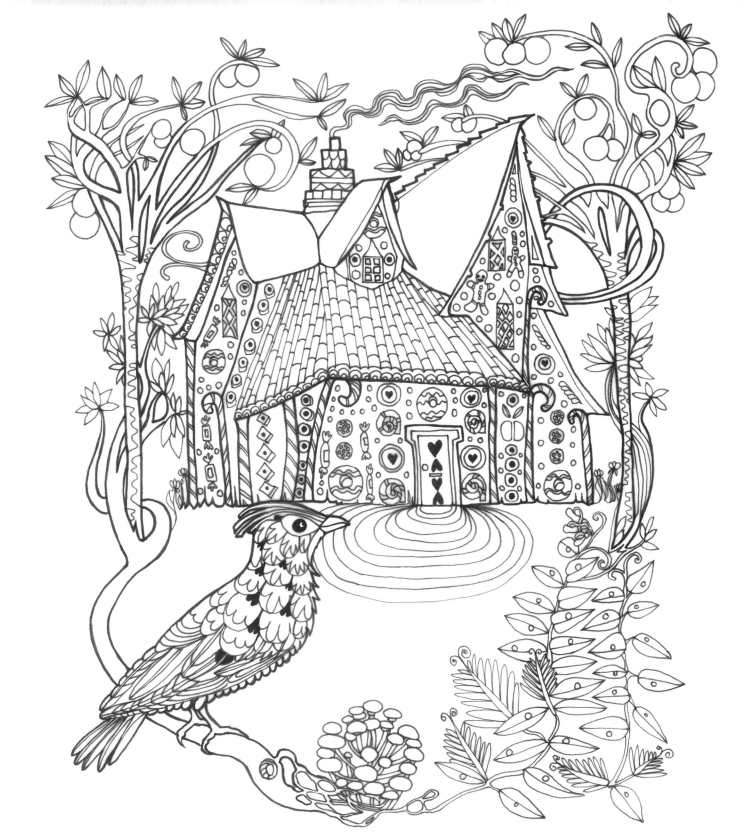

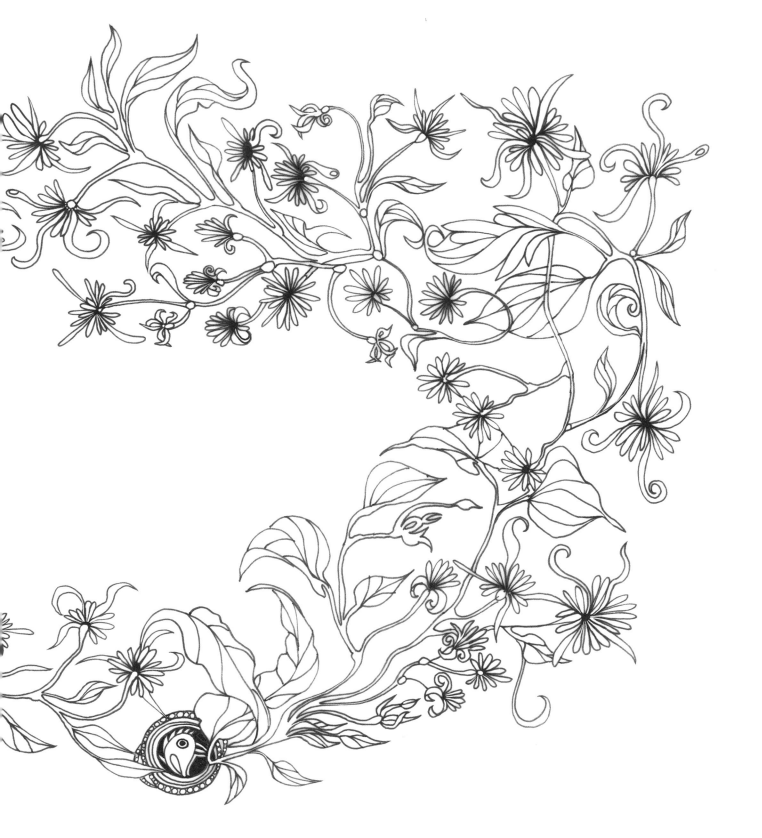

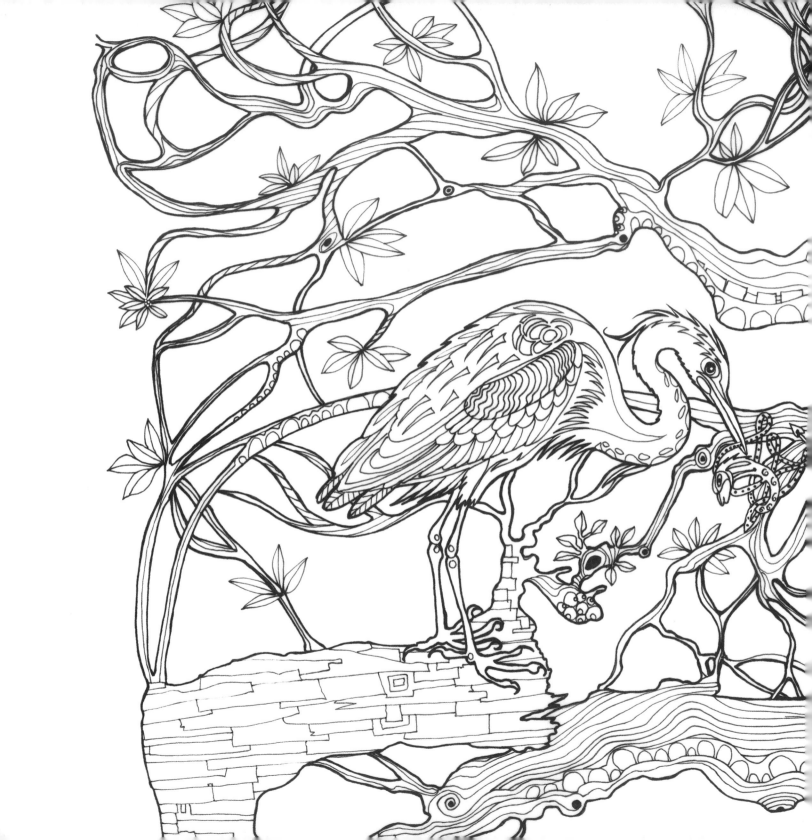

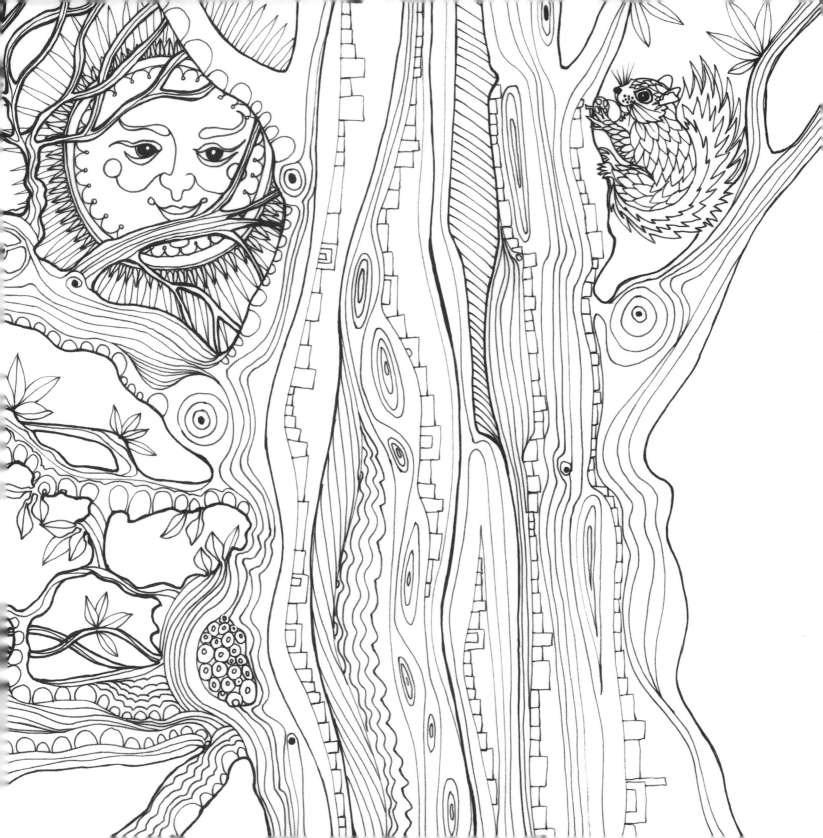

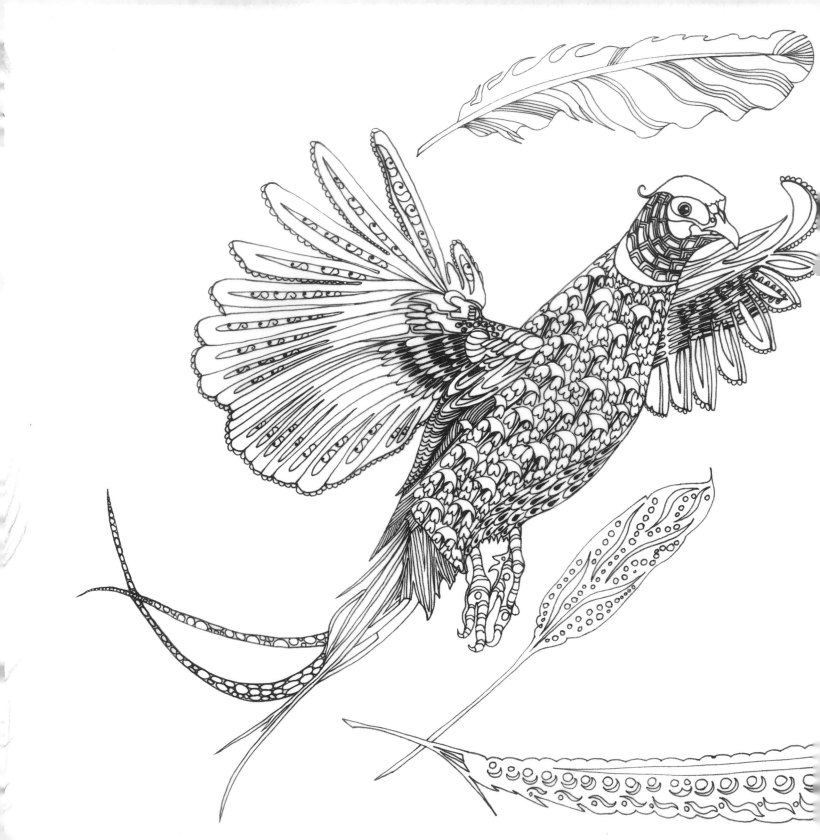

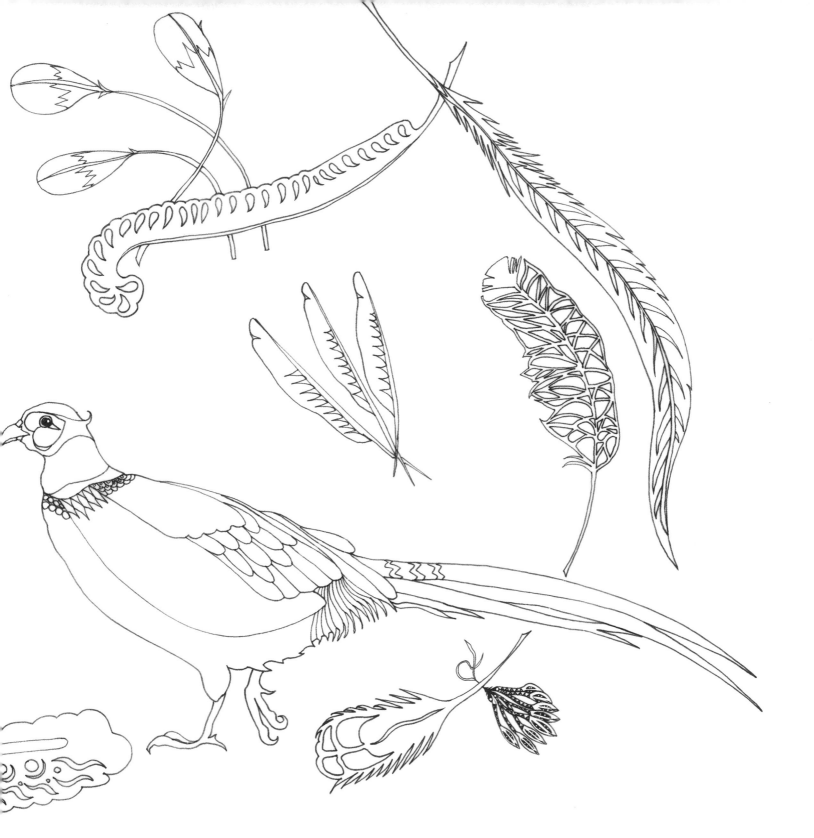

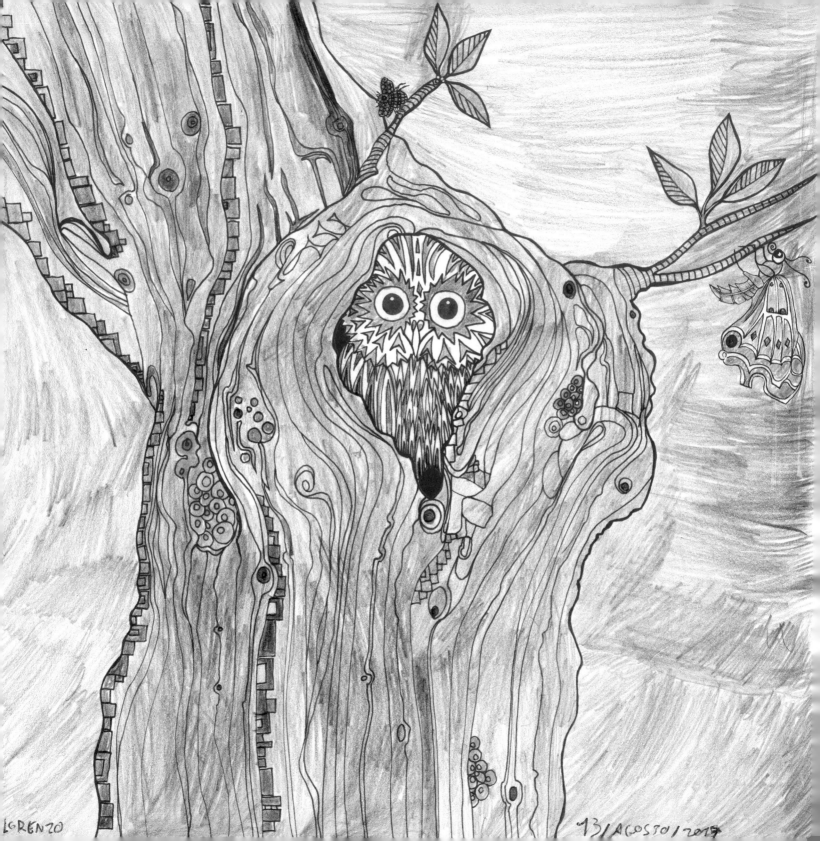

LORENZO 13/AGOSTO/2015

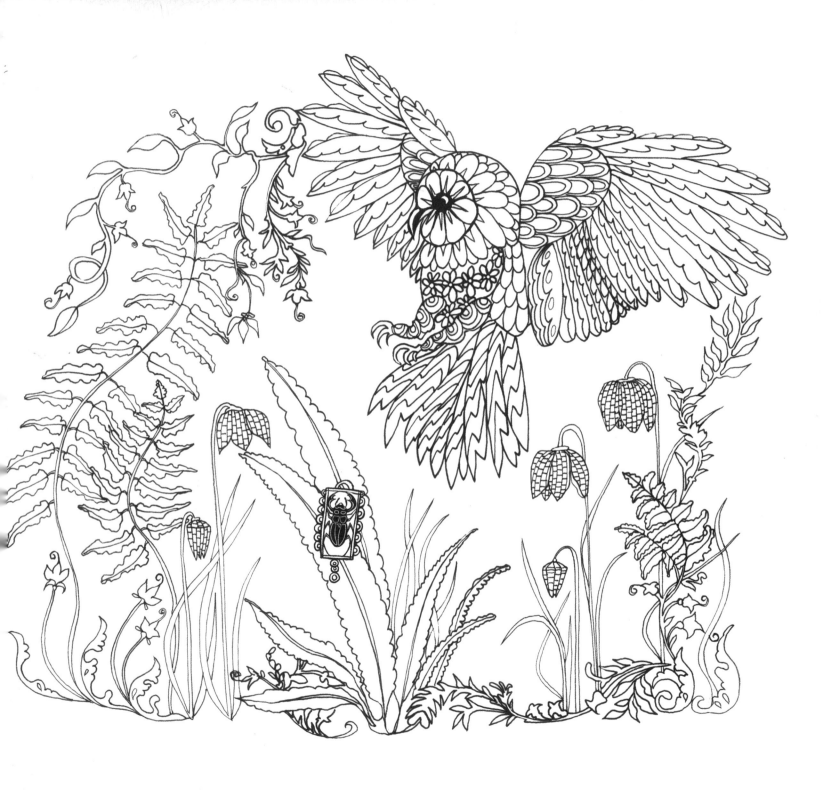

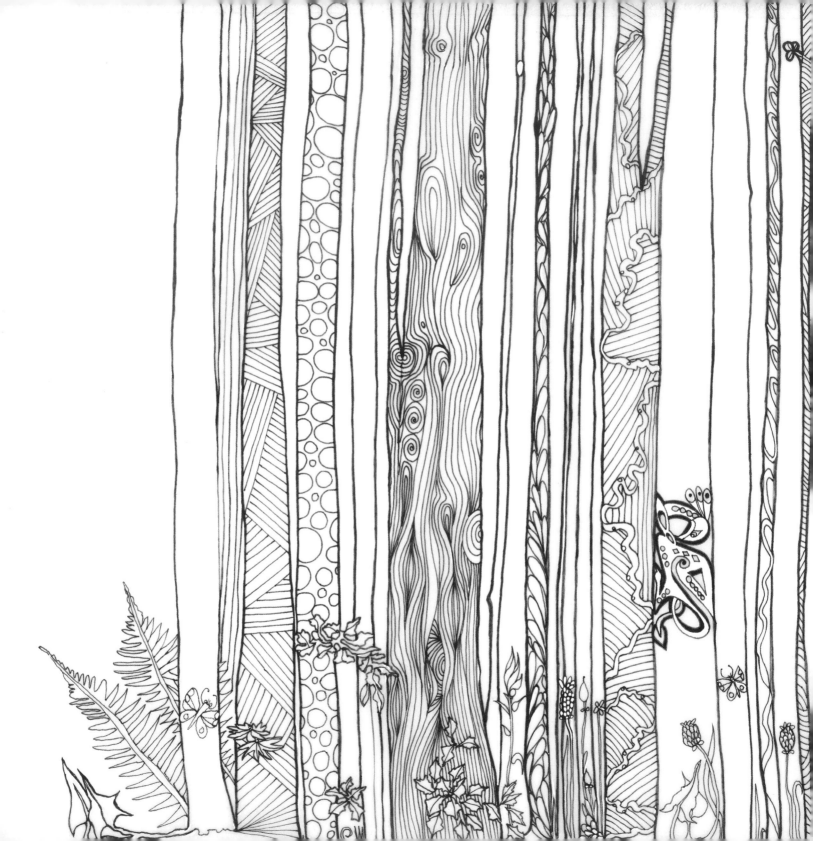

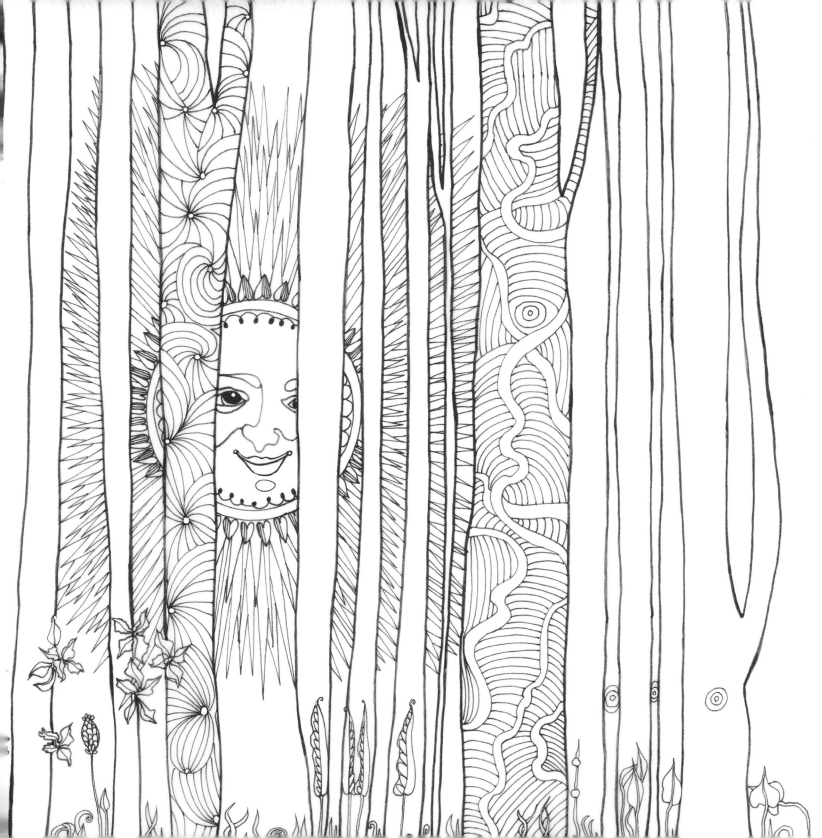

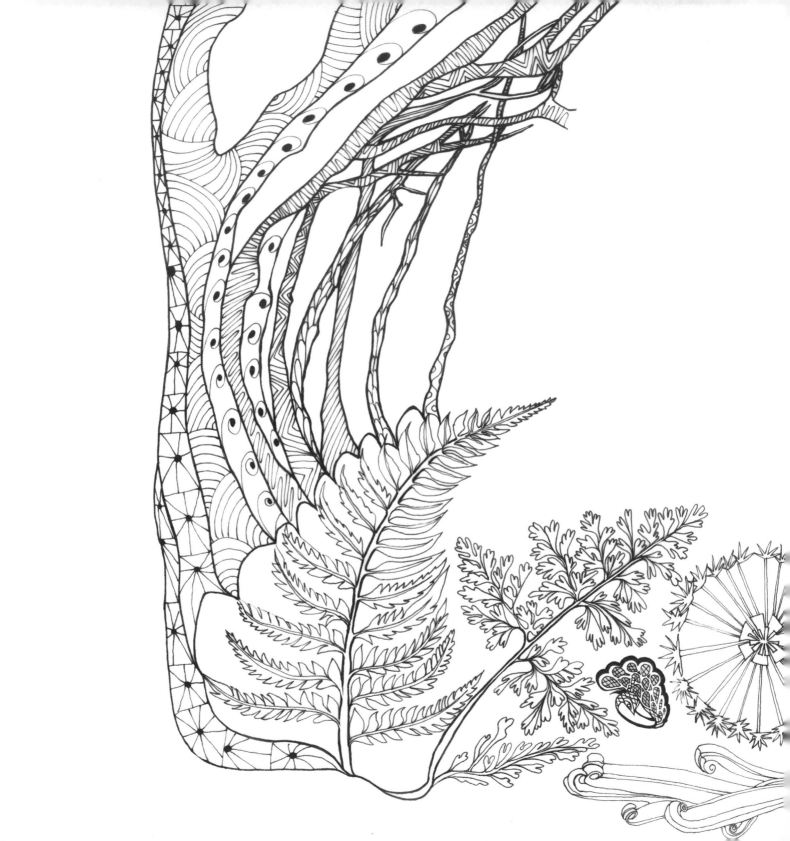

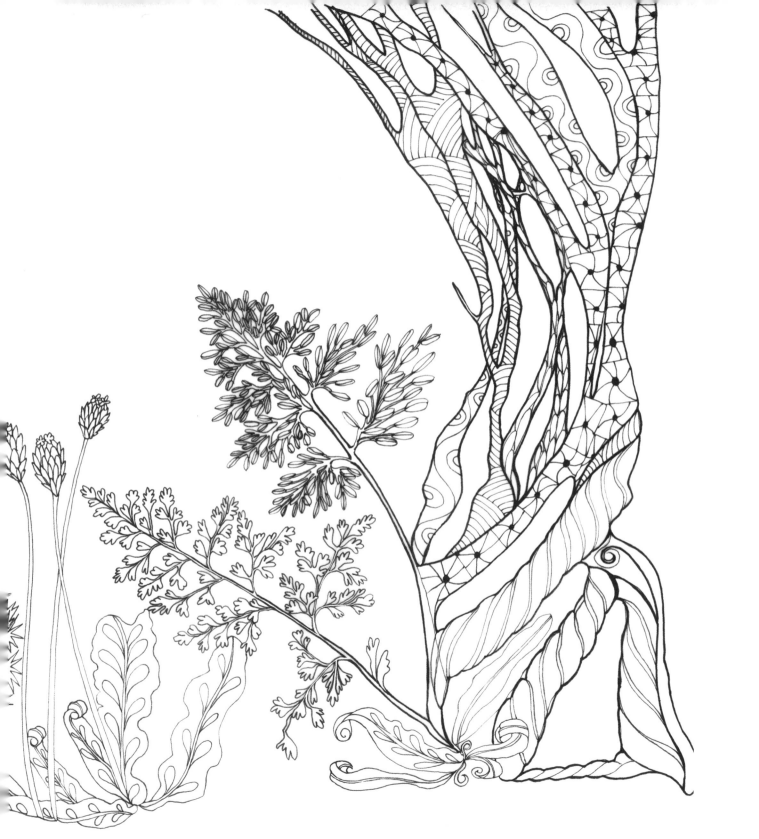

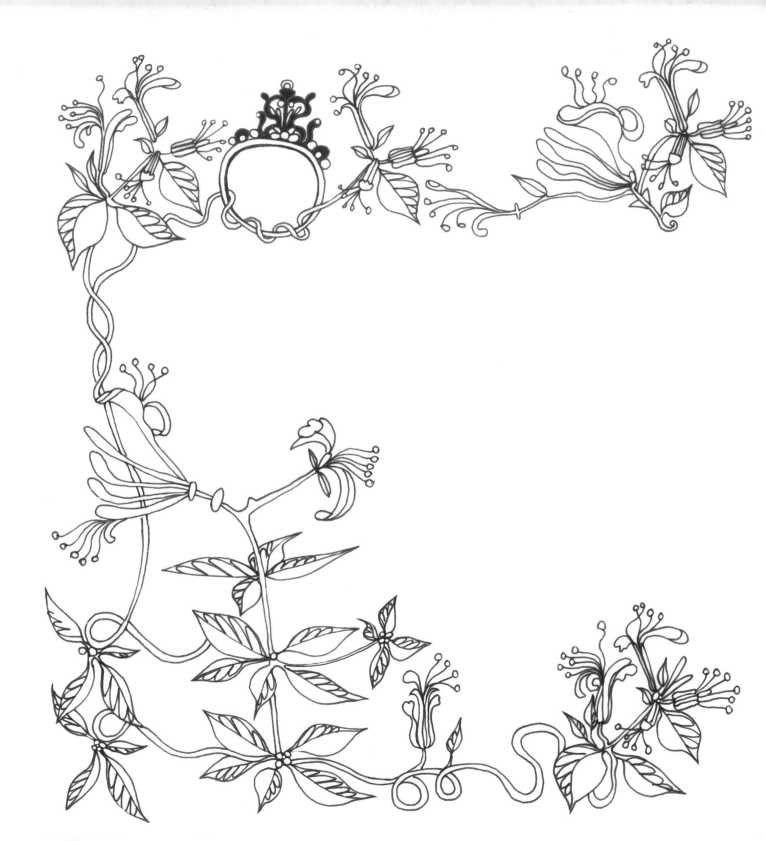

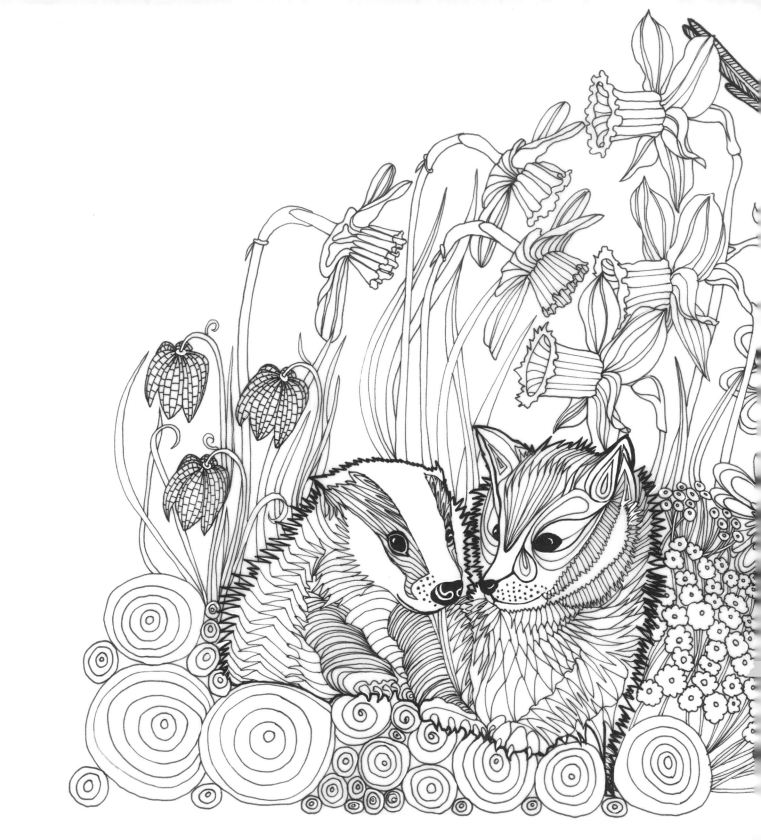

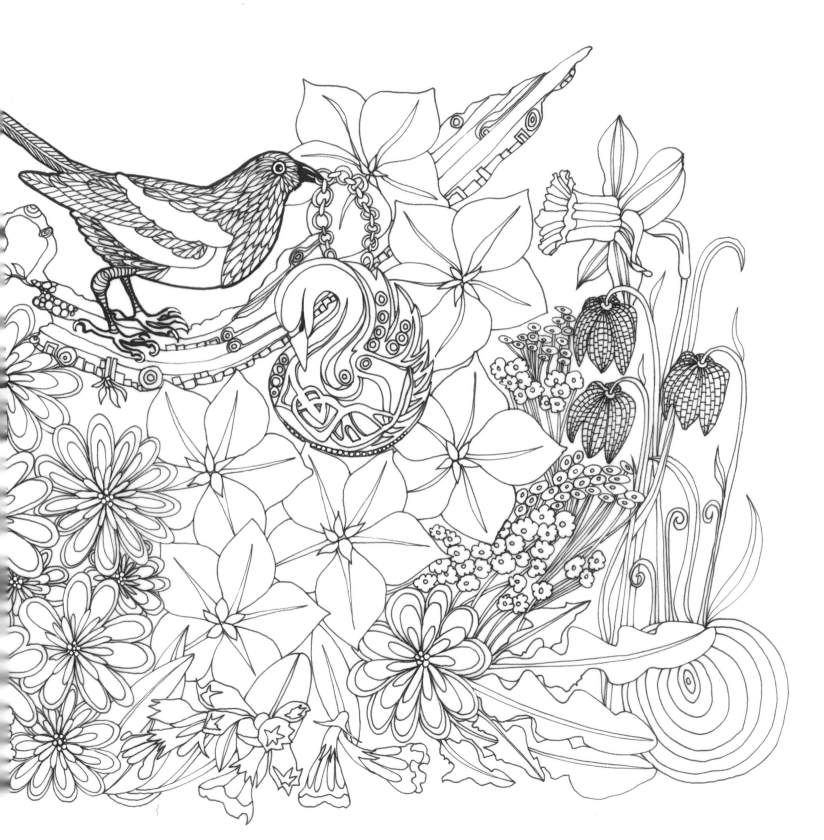

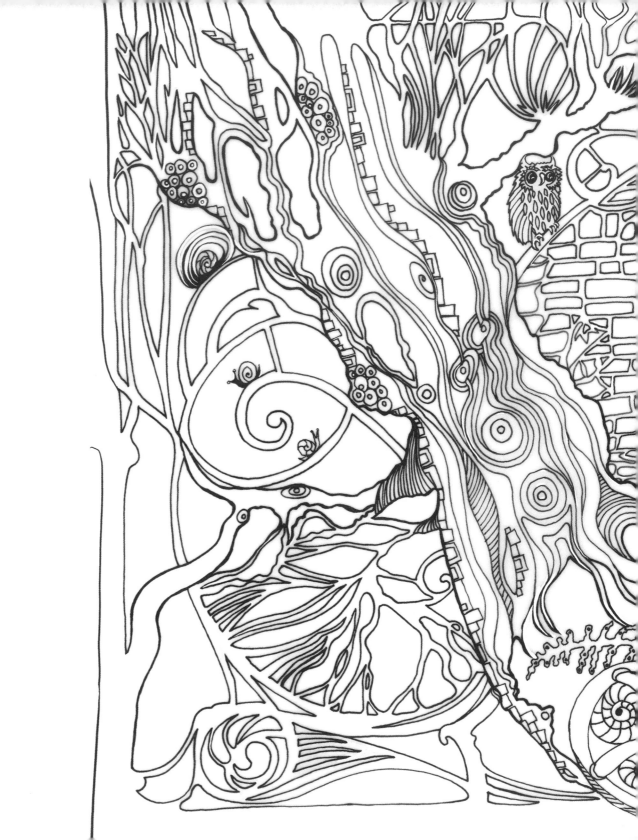

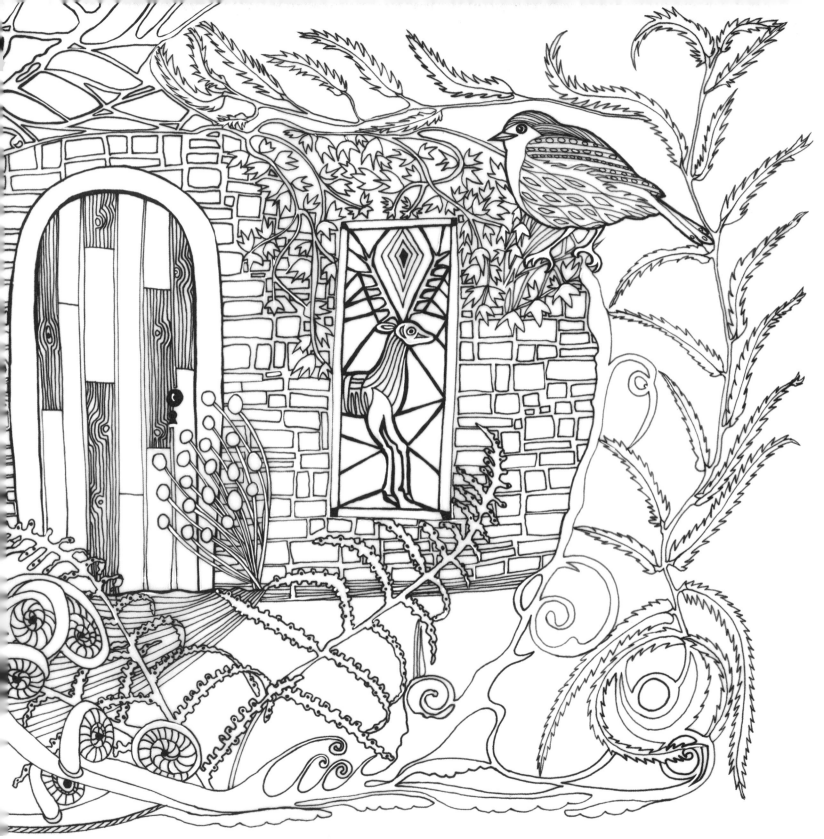

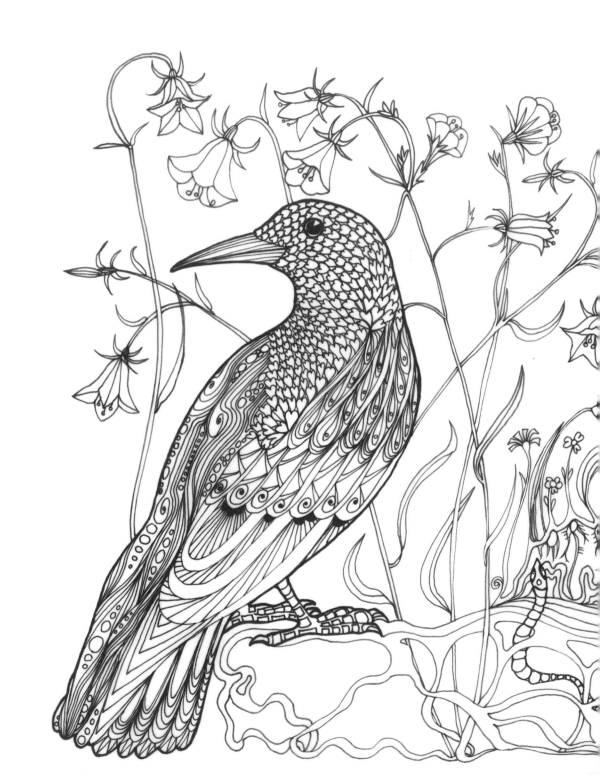

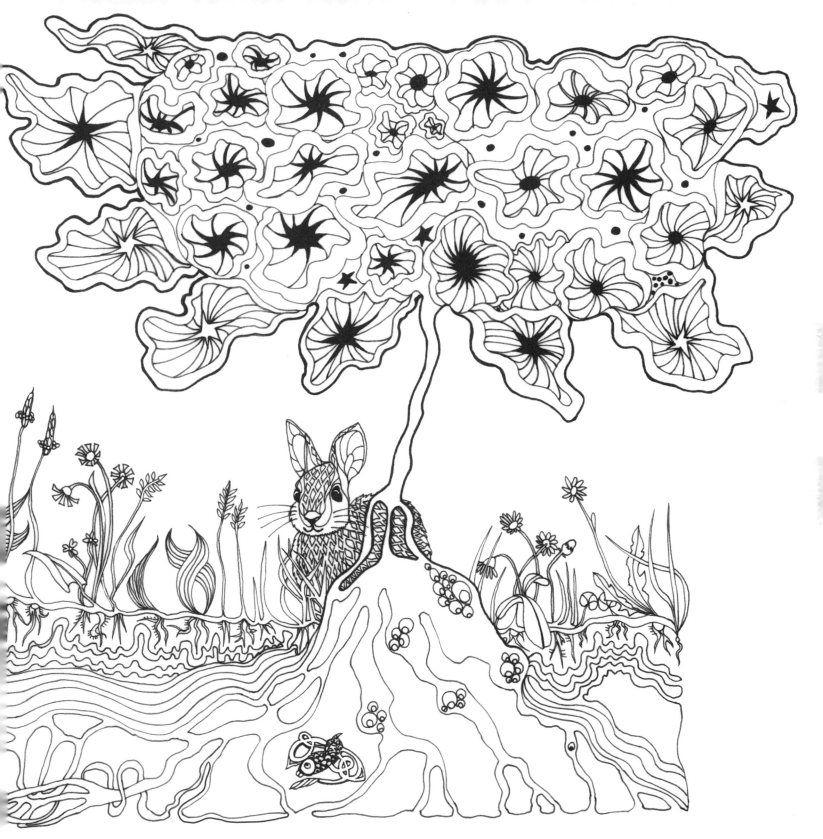

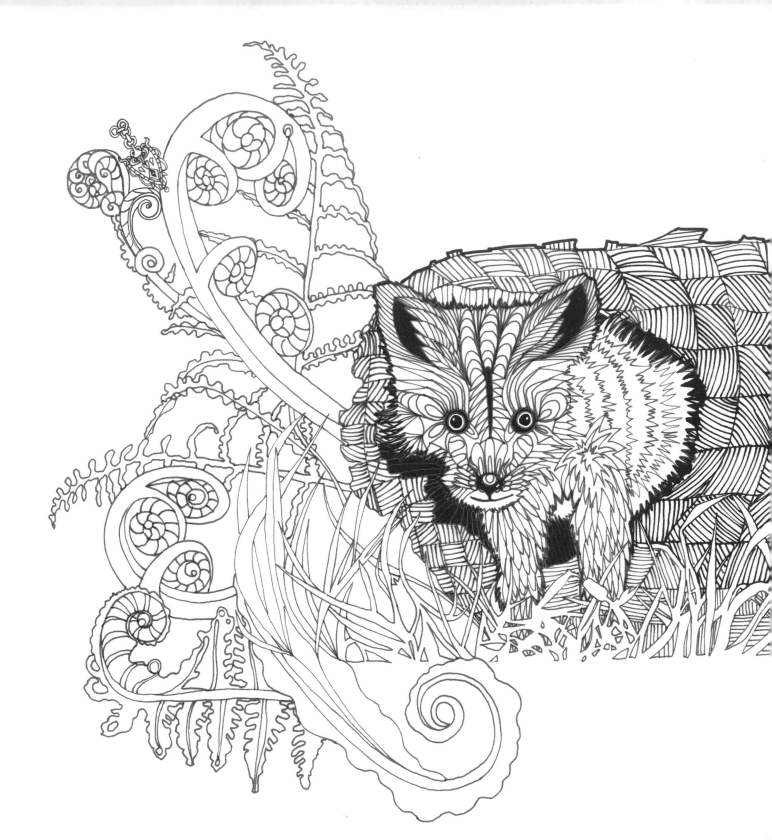

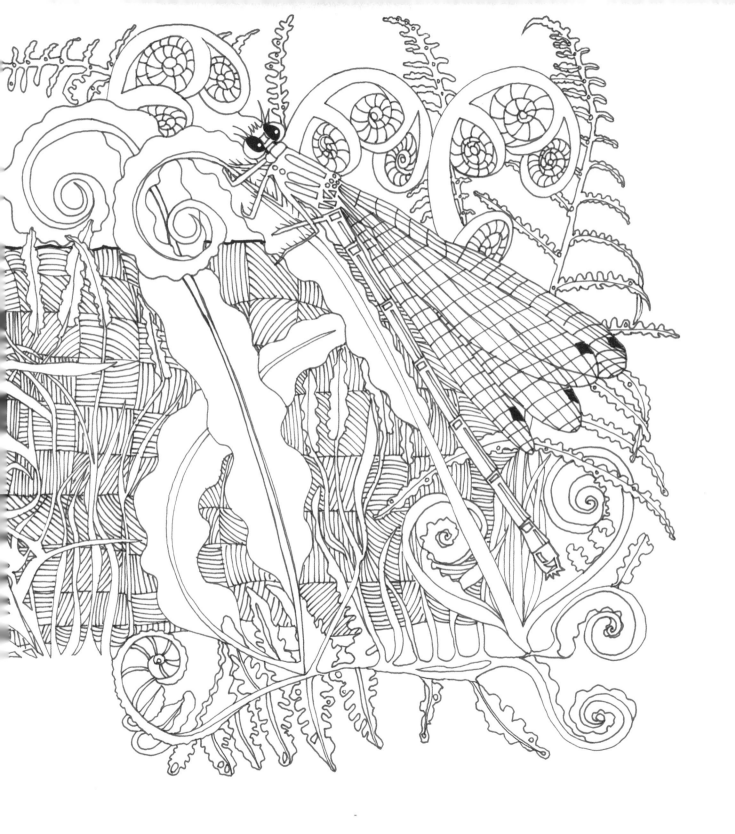

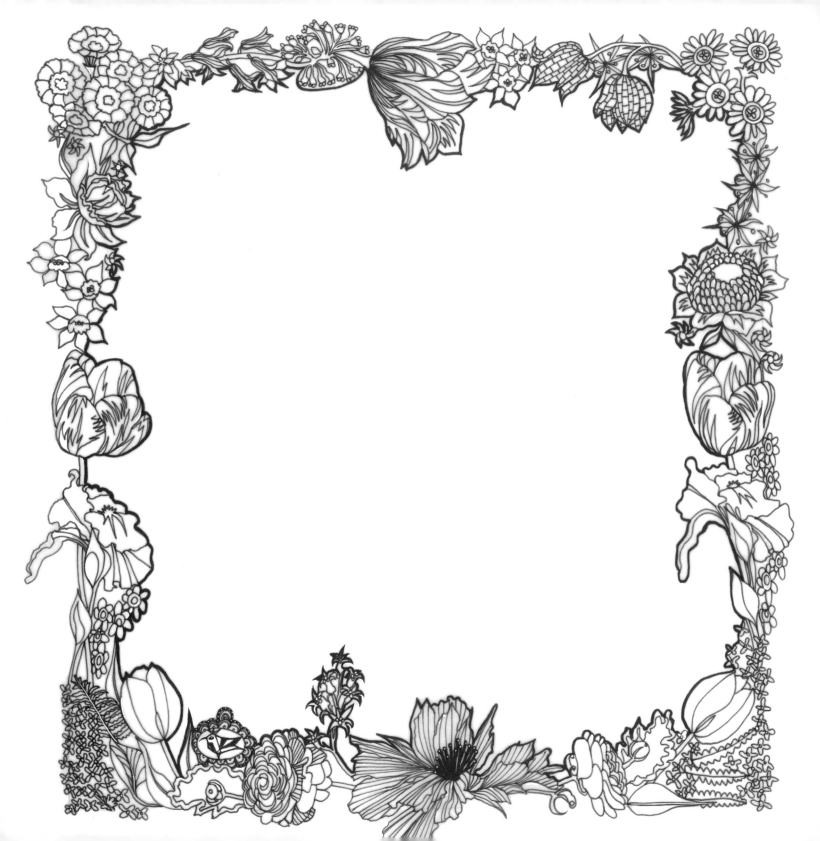

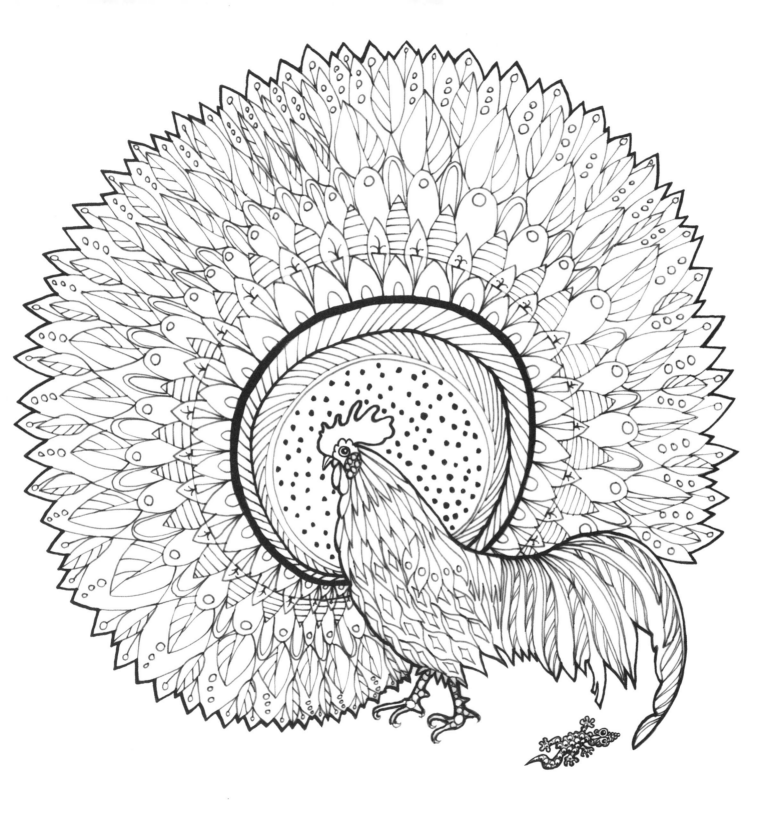

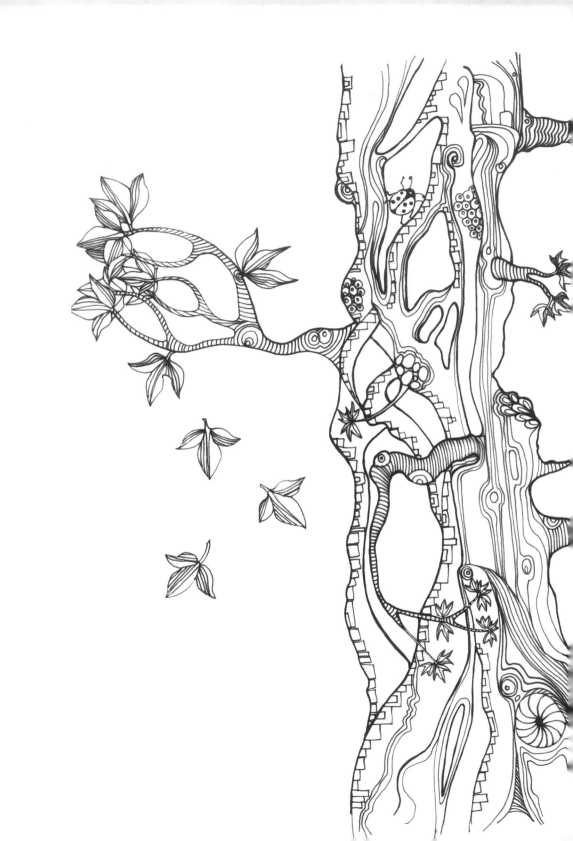

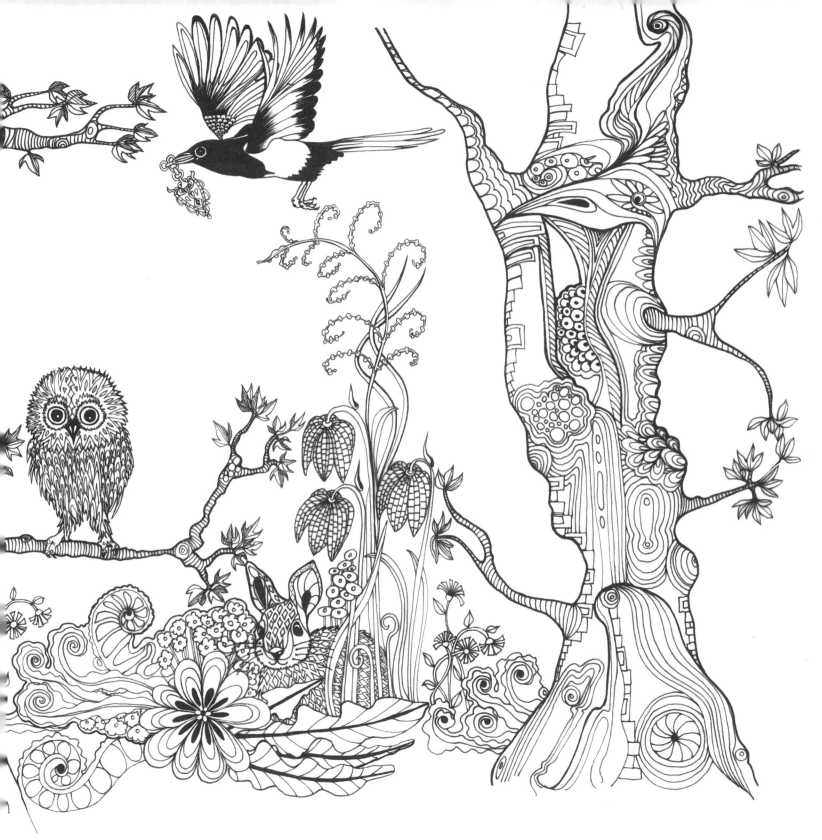

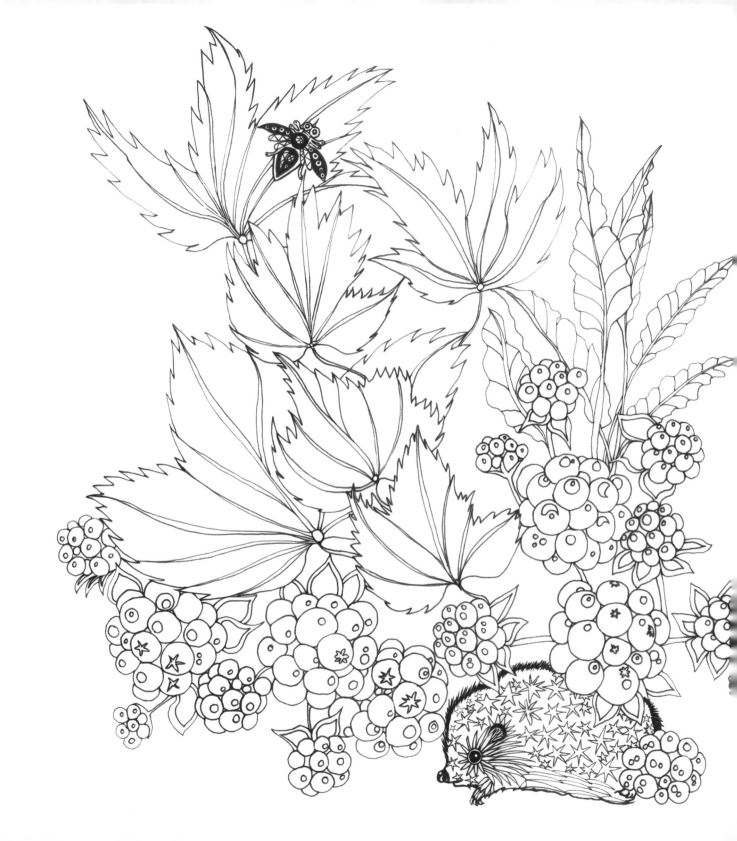

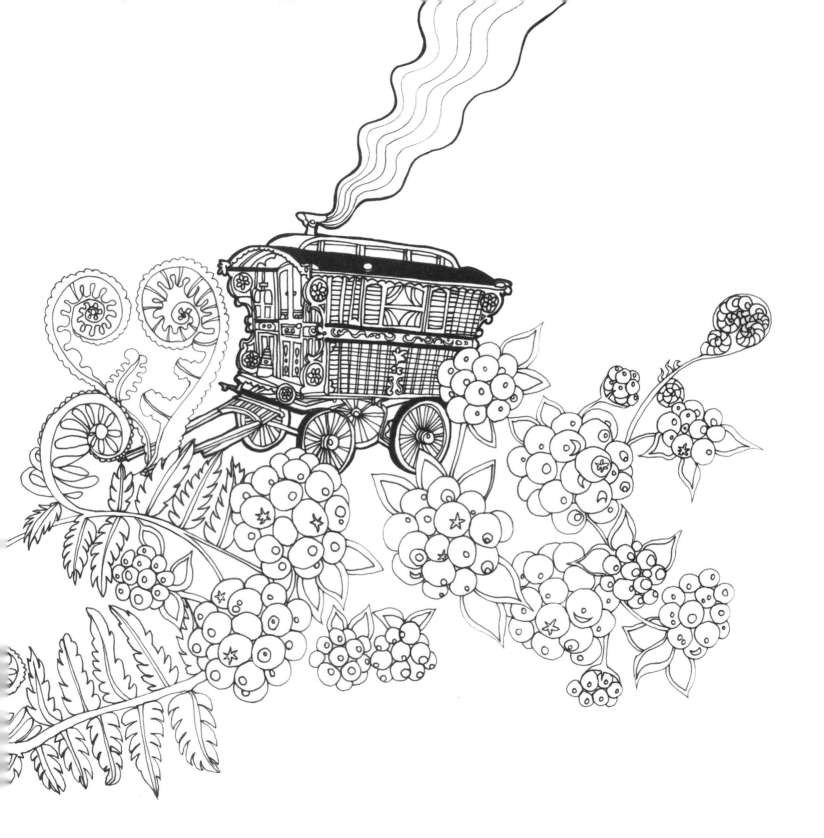

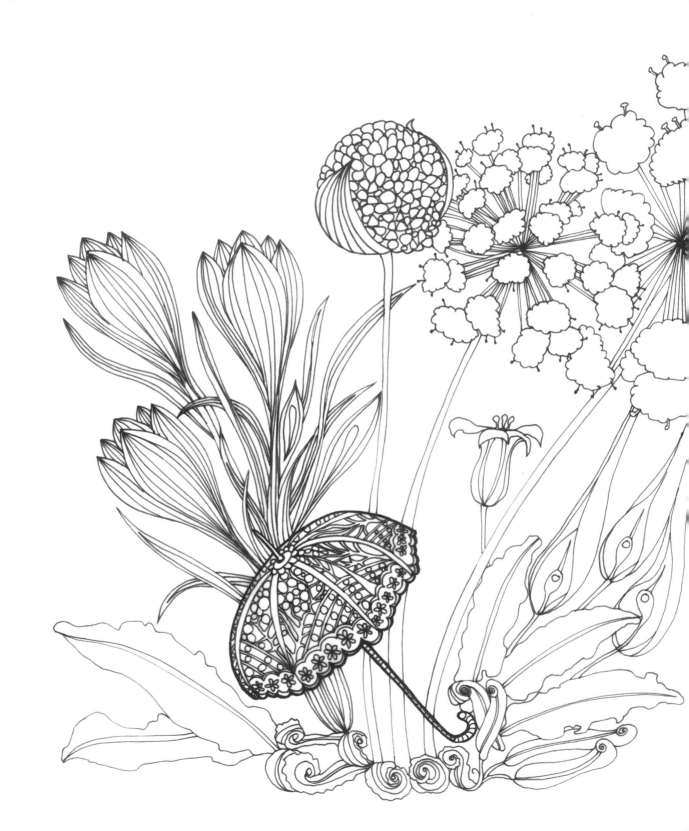

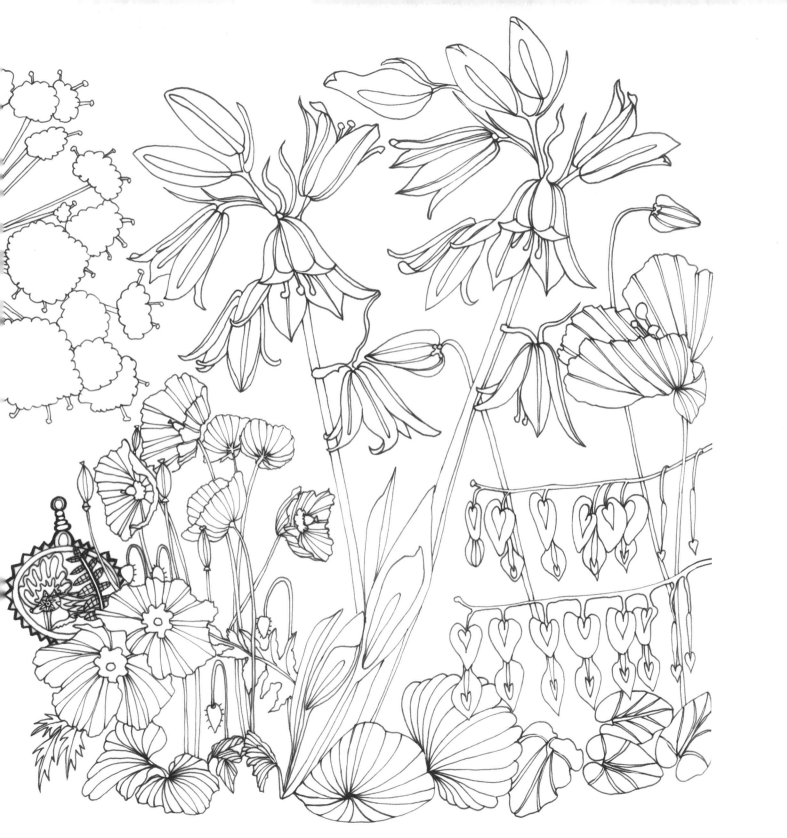

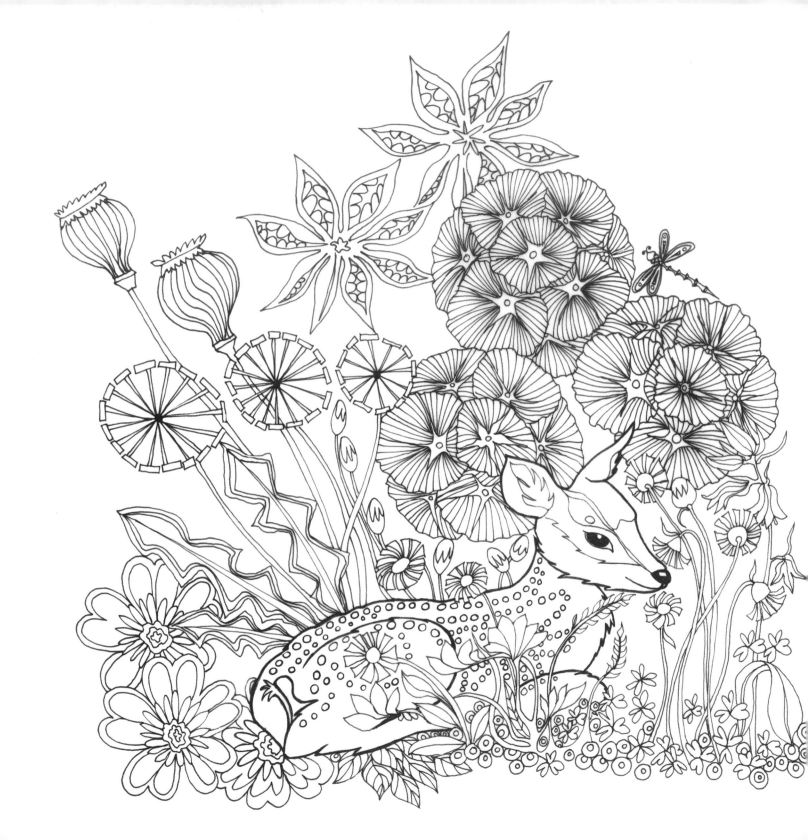

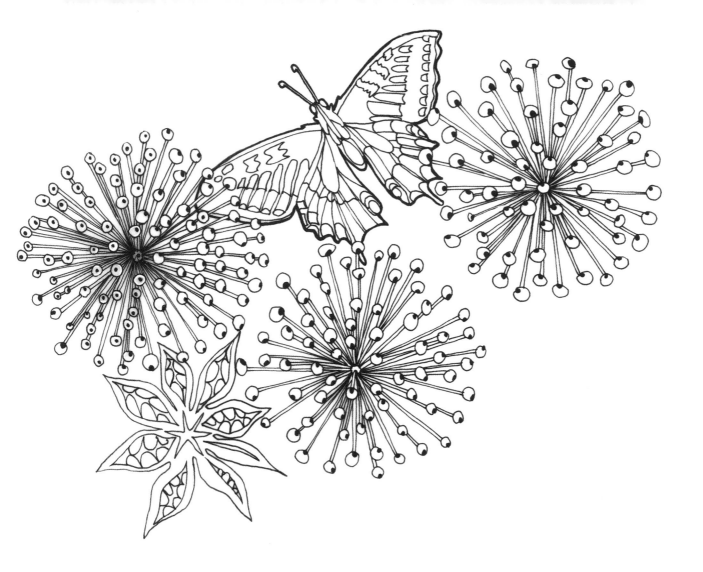

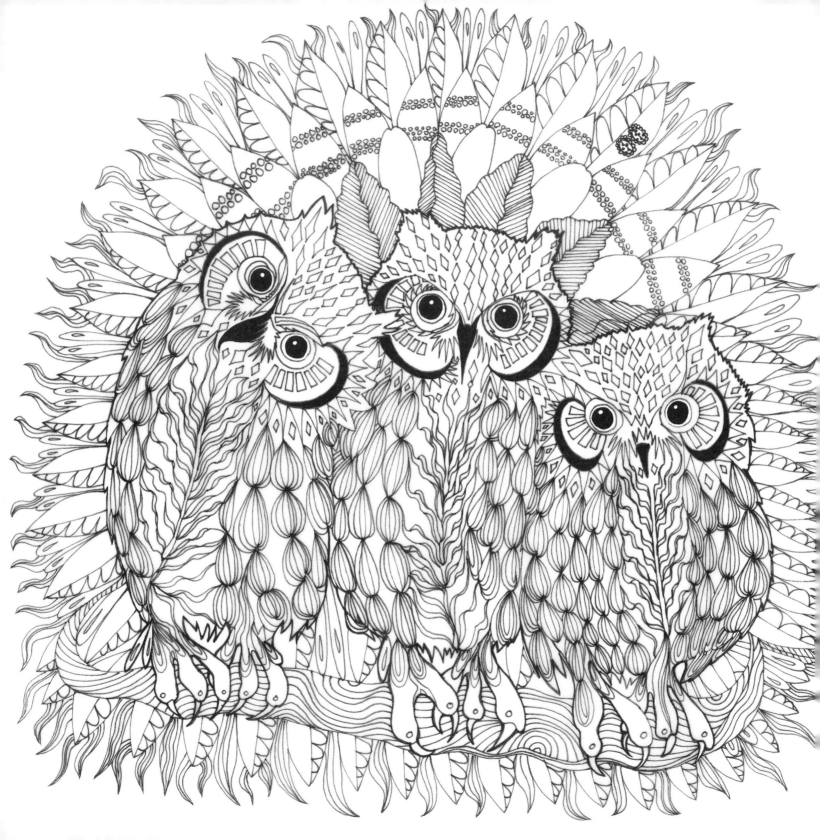

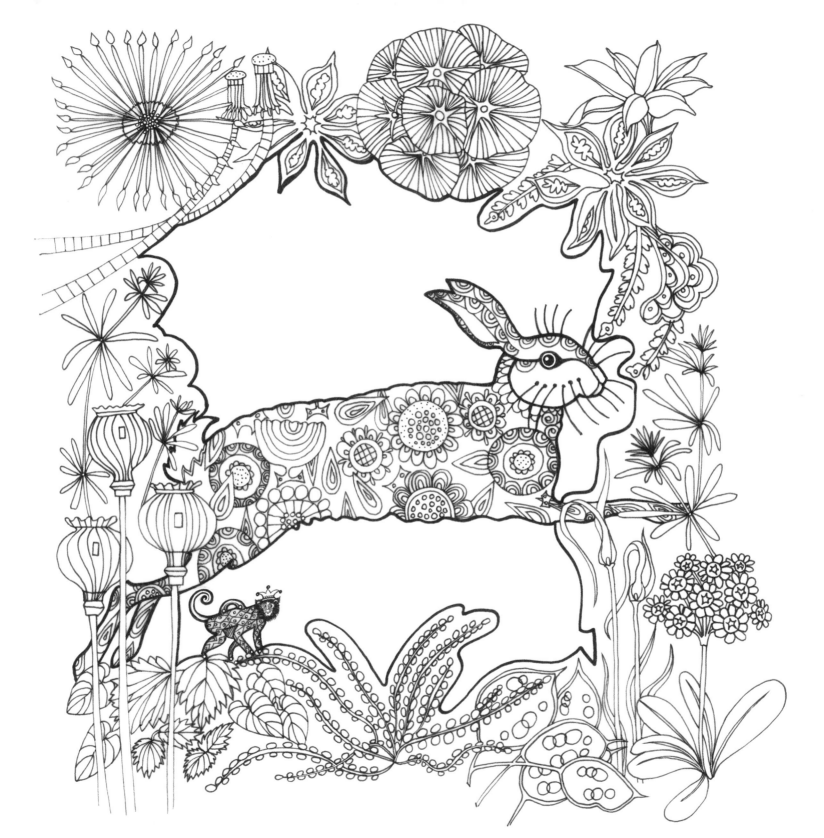

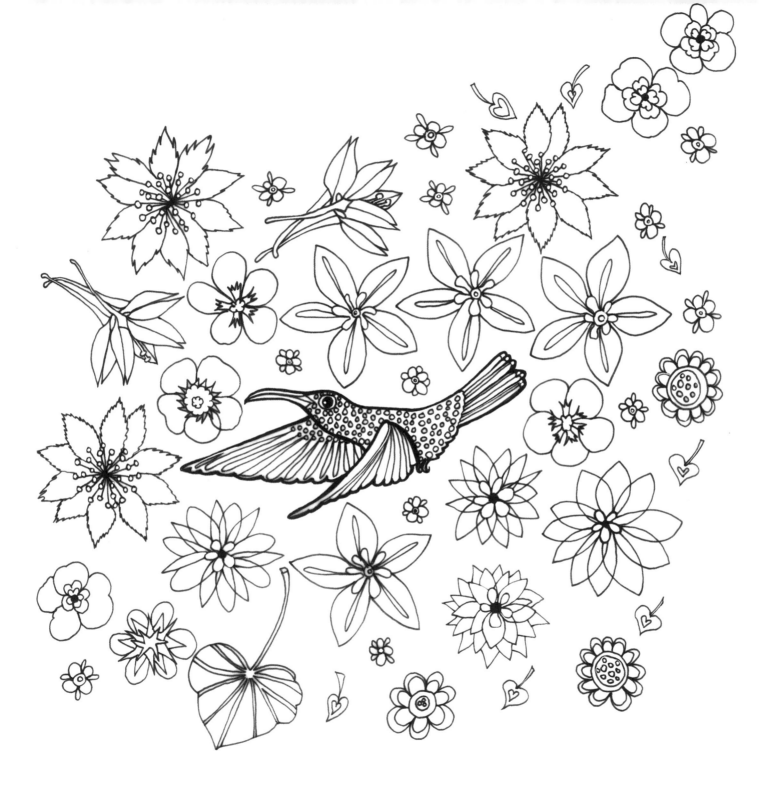

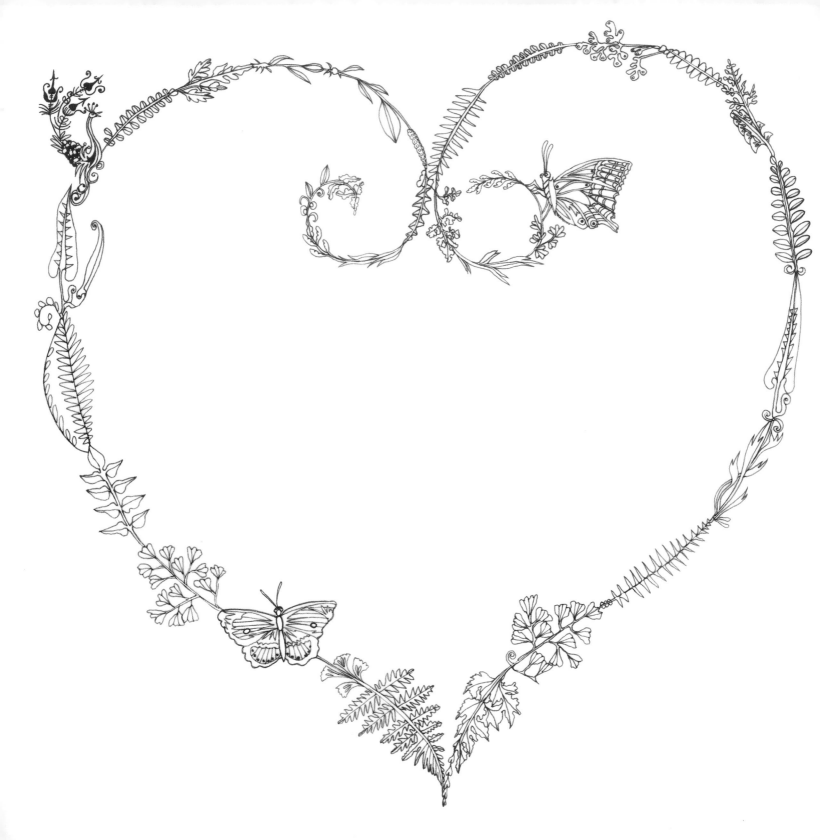

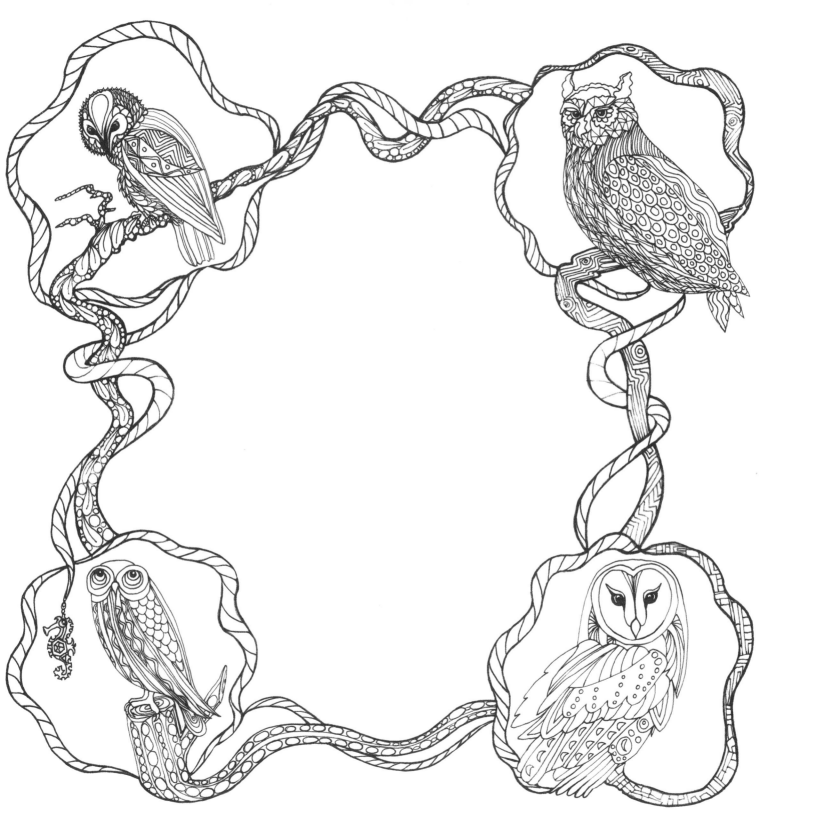

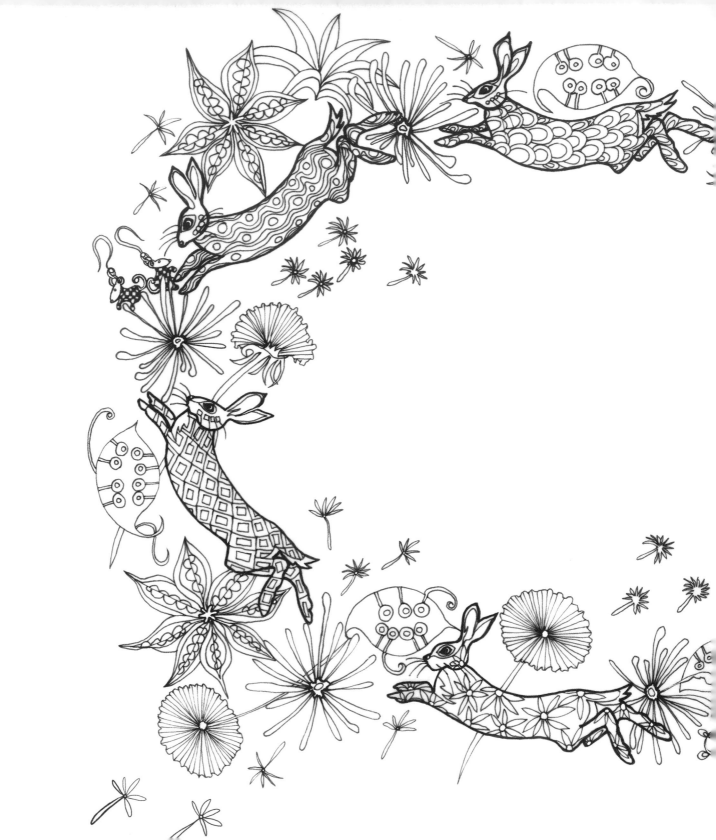

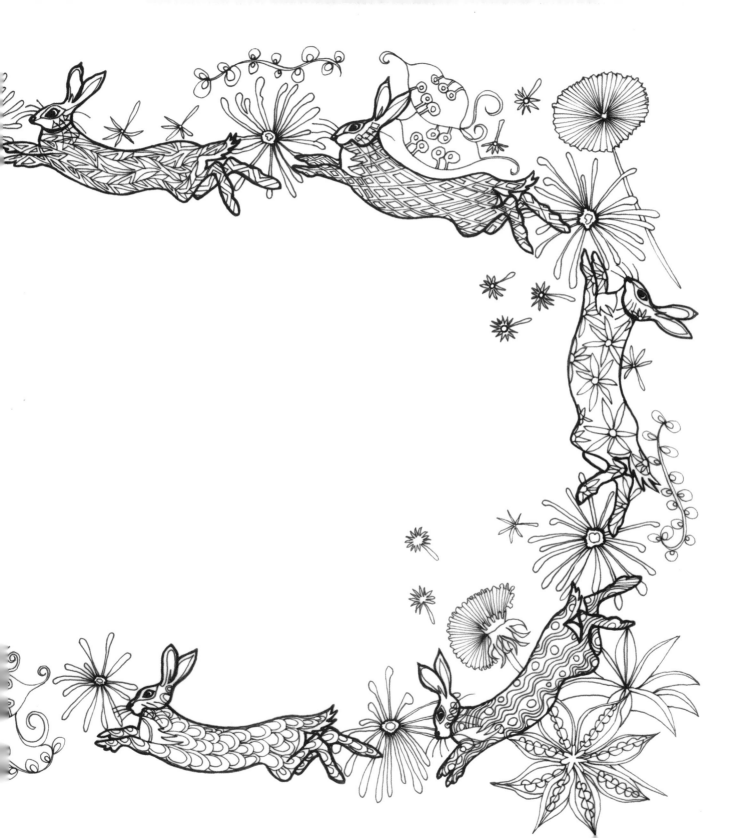

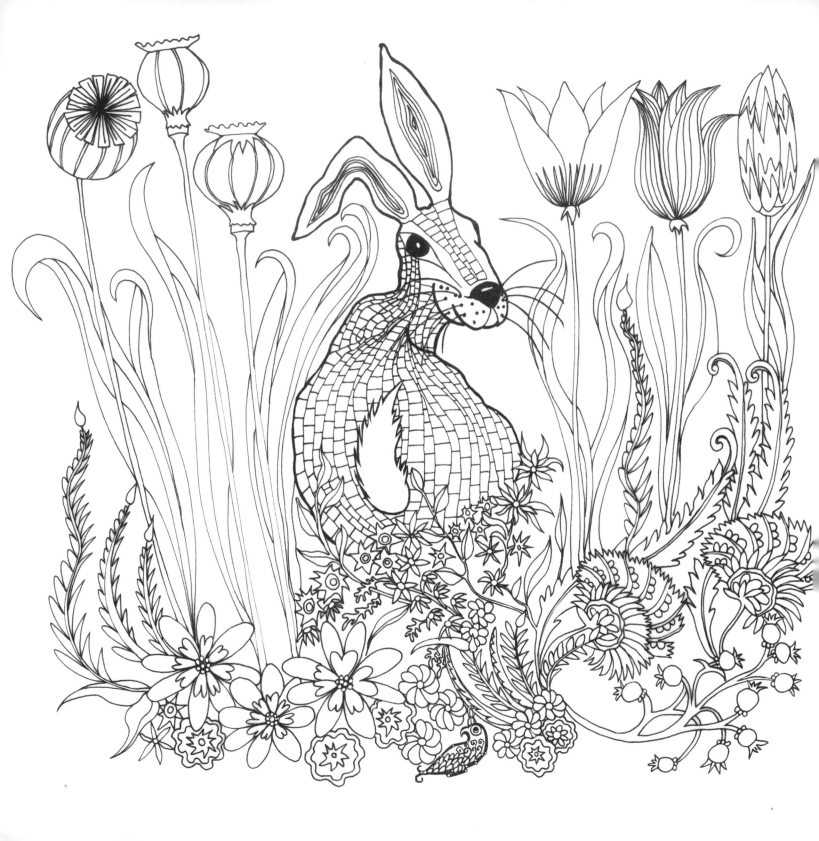

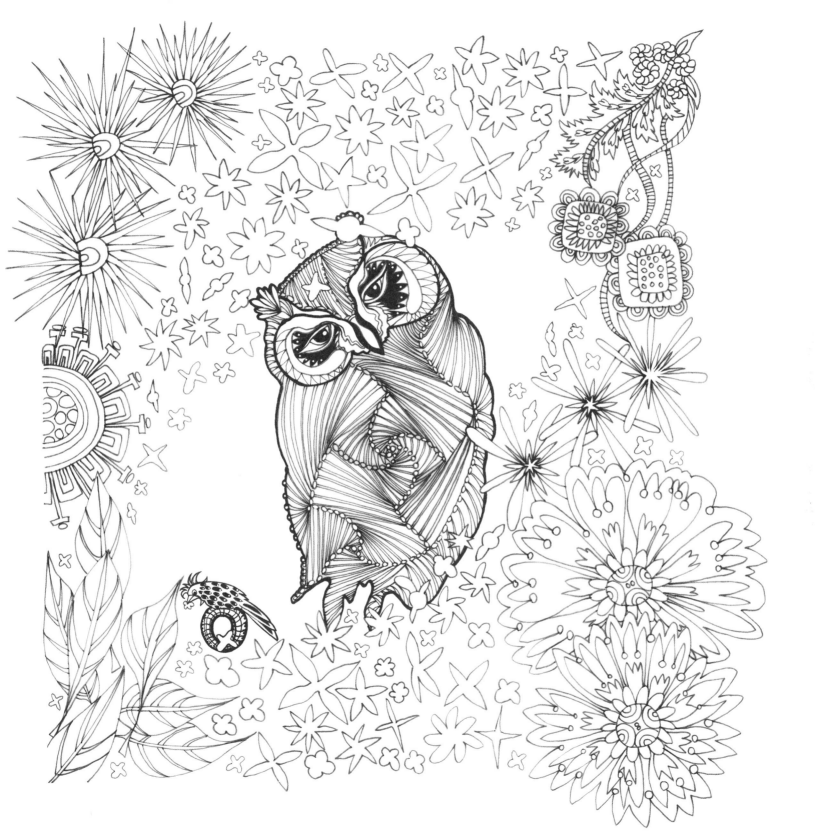

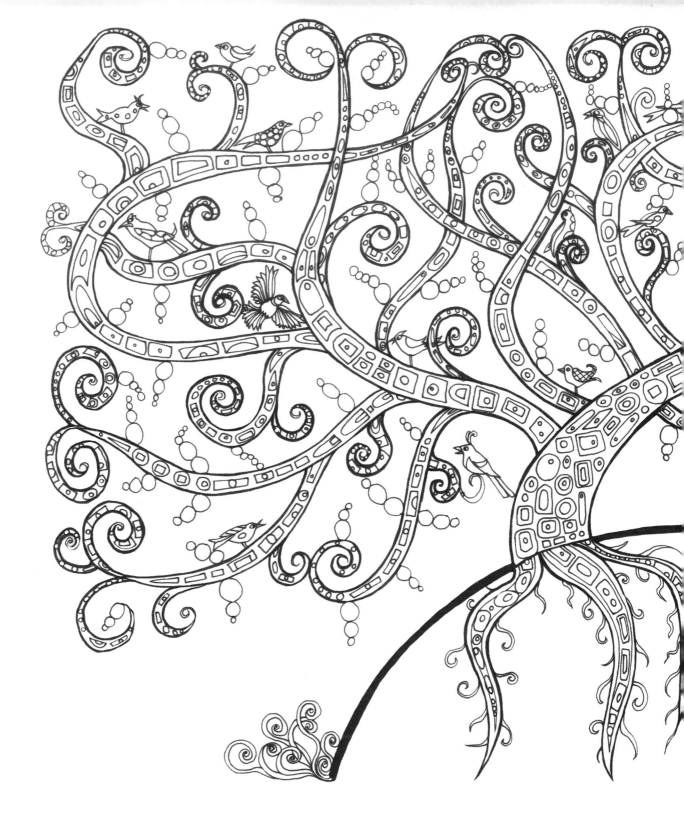

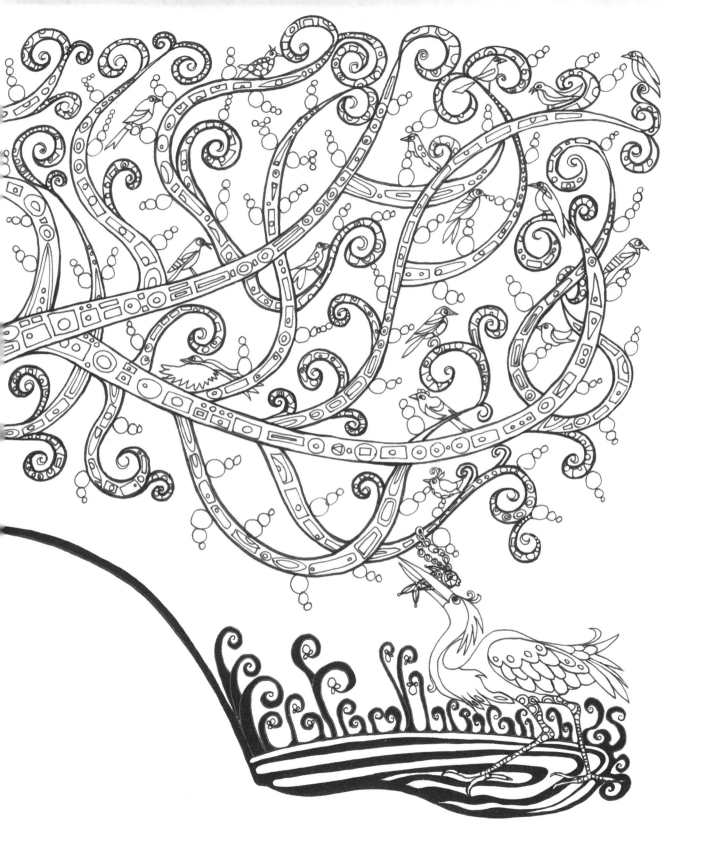

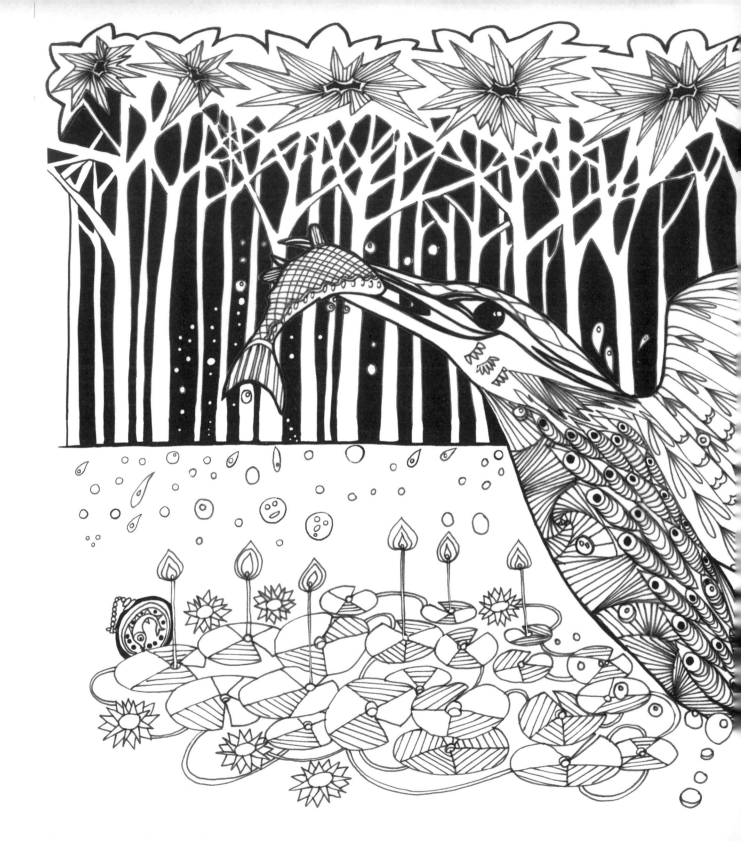

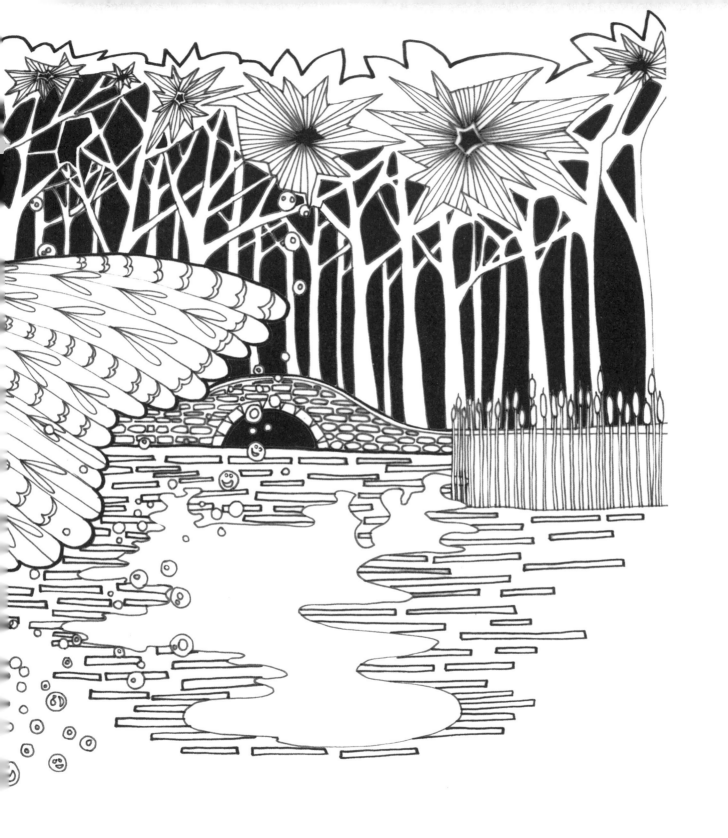

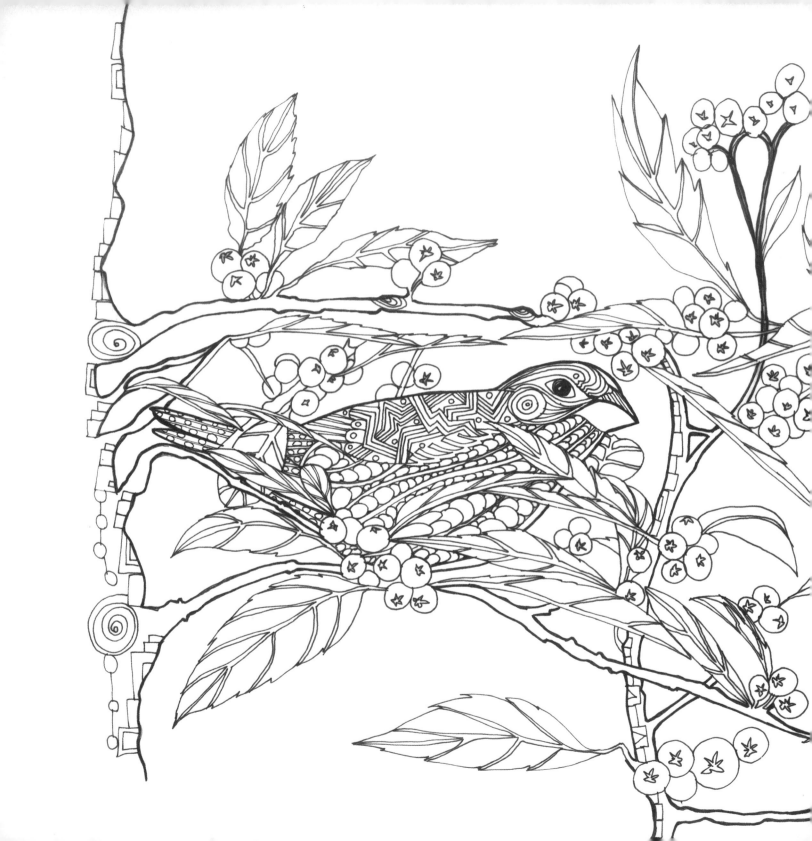

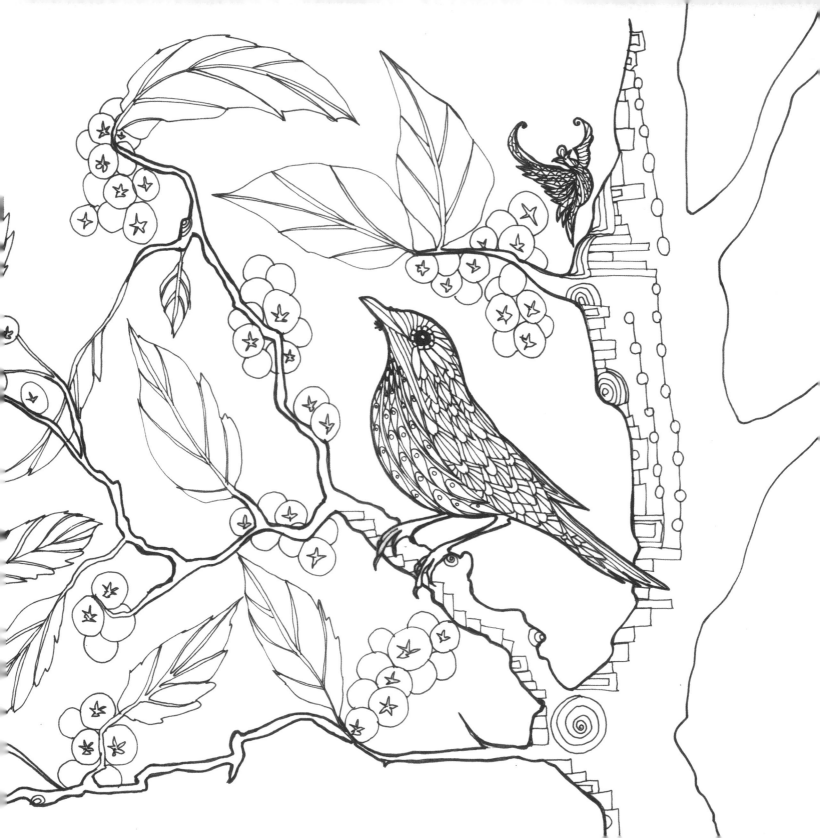

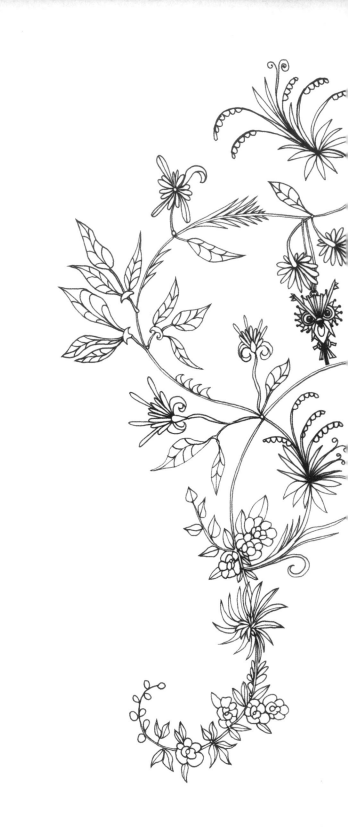

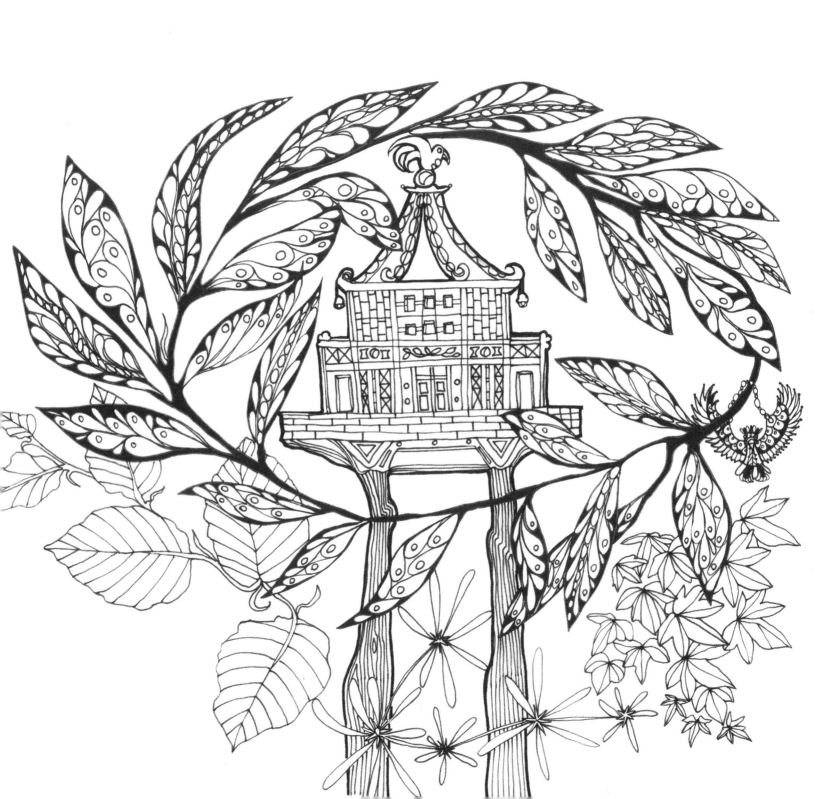

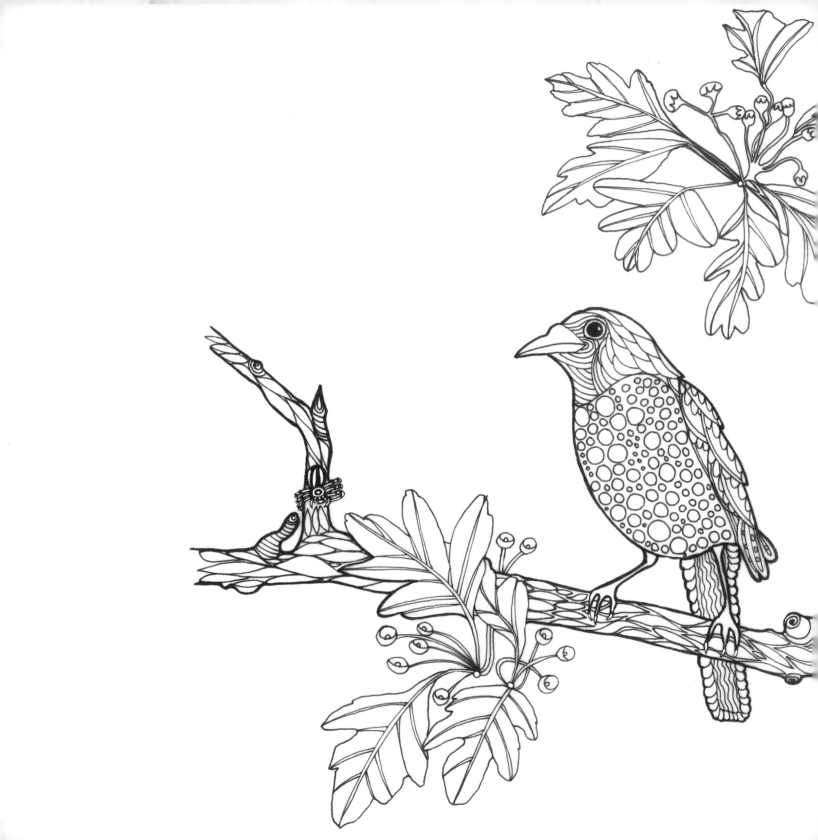

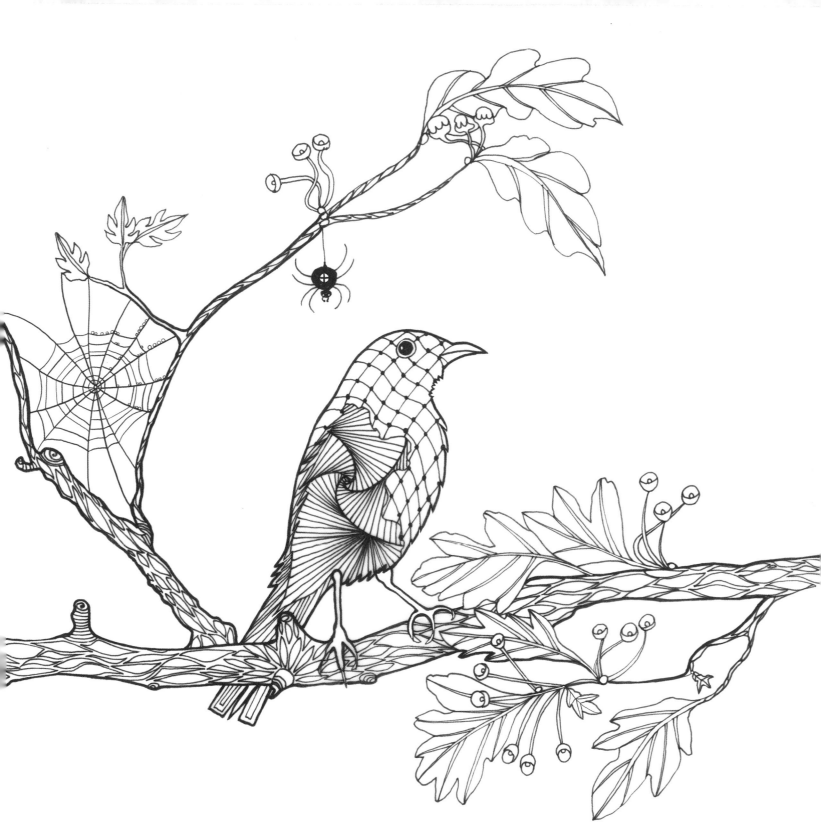

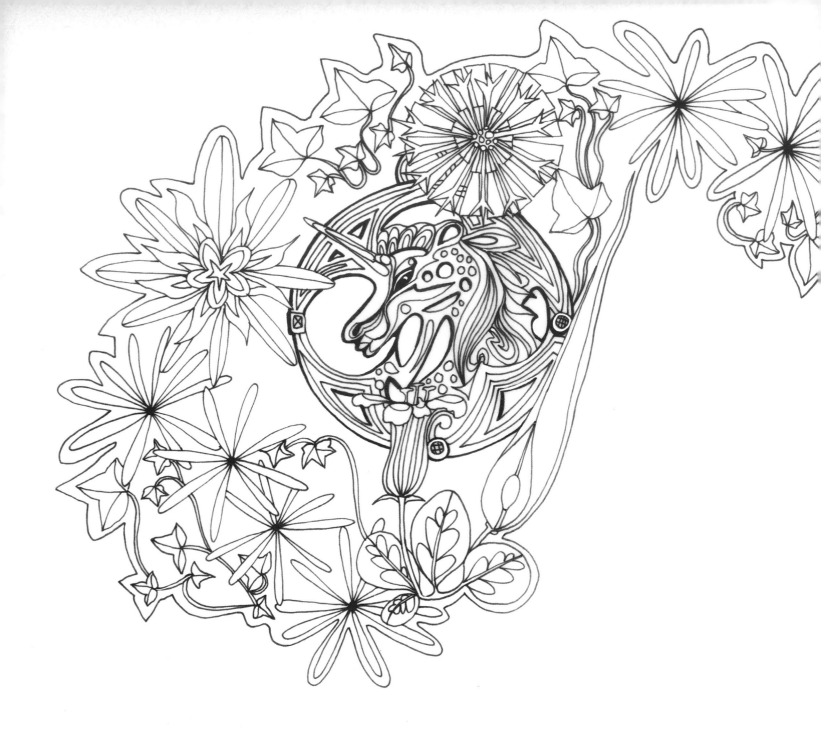

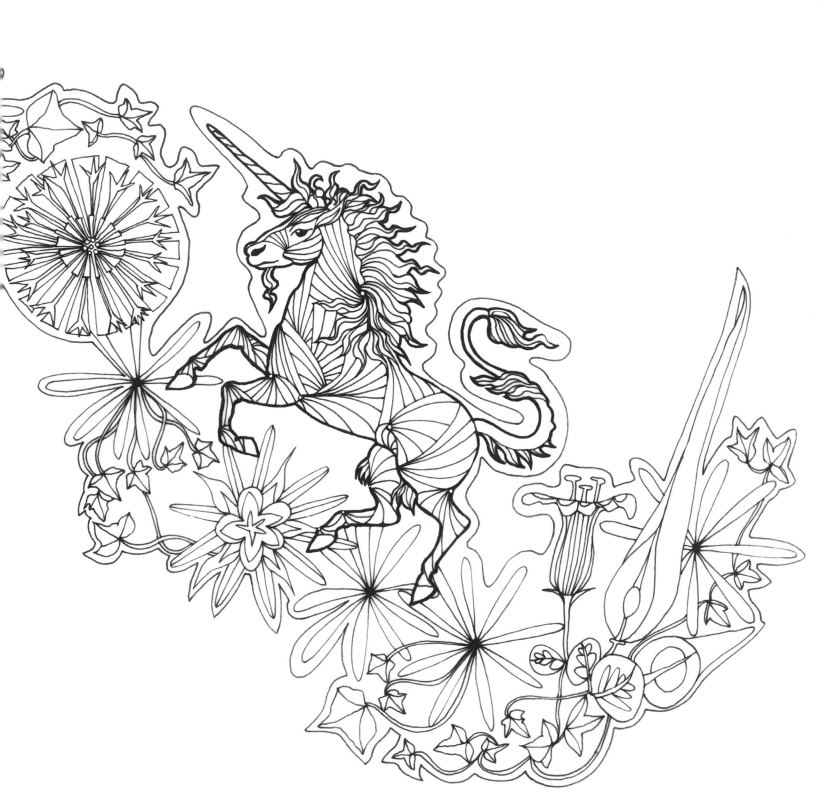

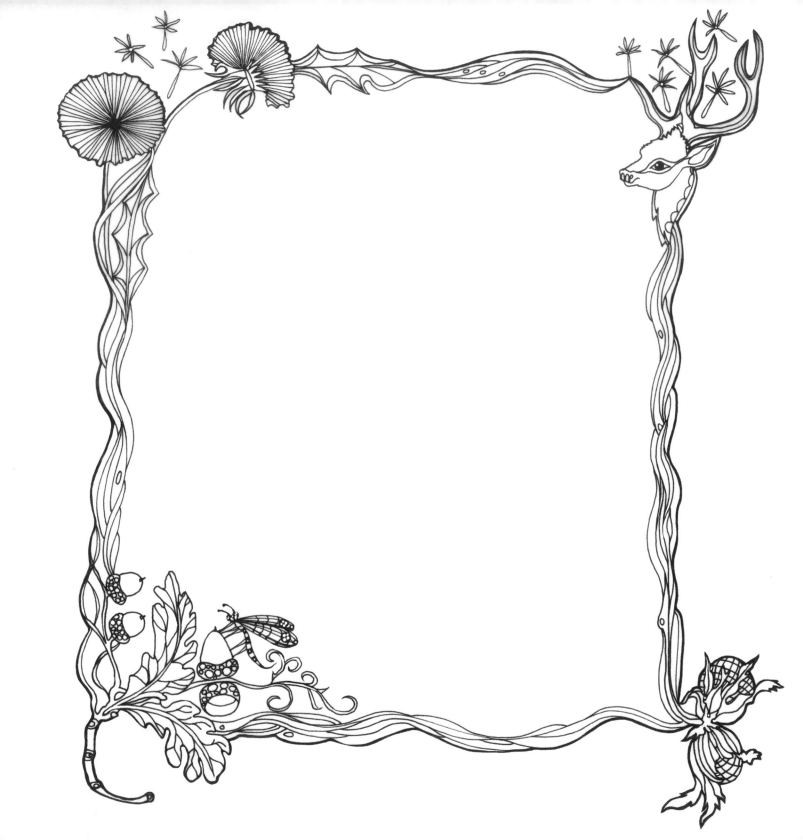

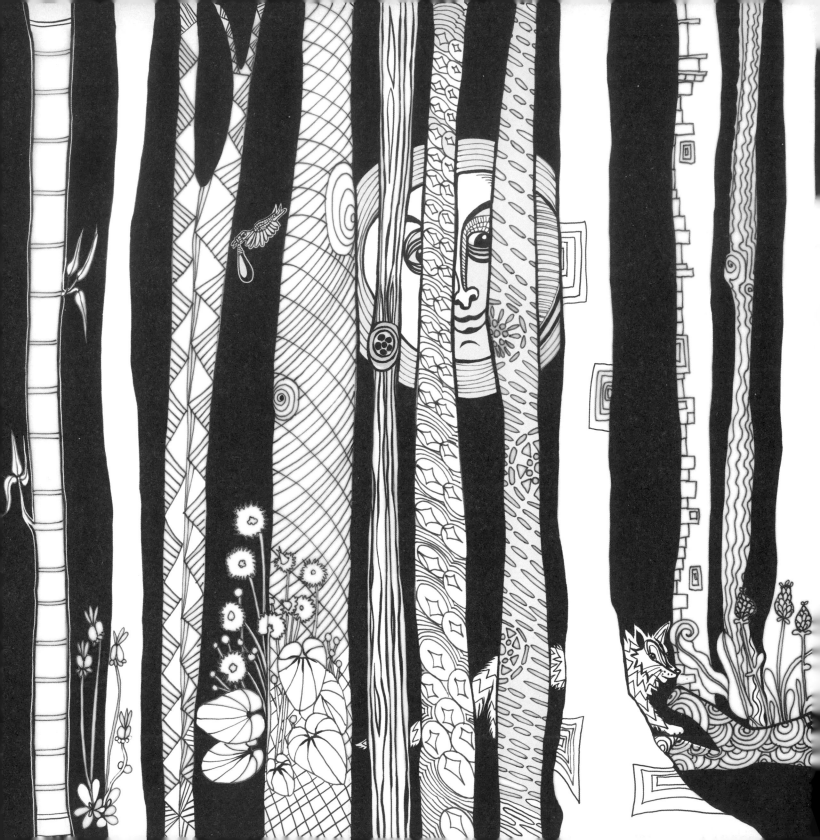

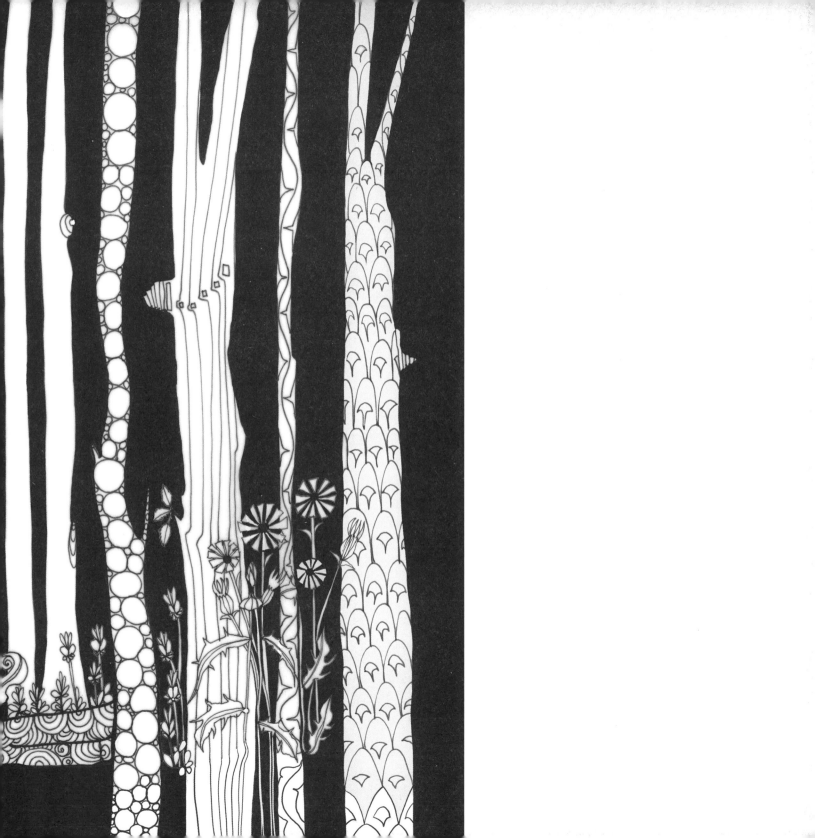

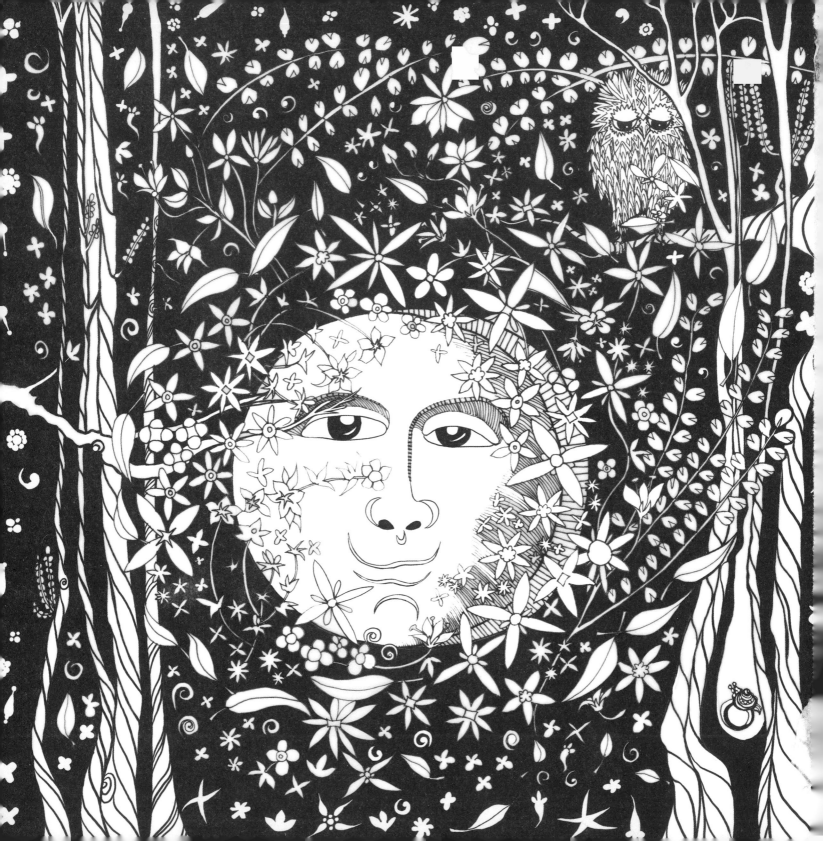